DRAWING FAERIES™
KEYS TO THE KINGDOM

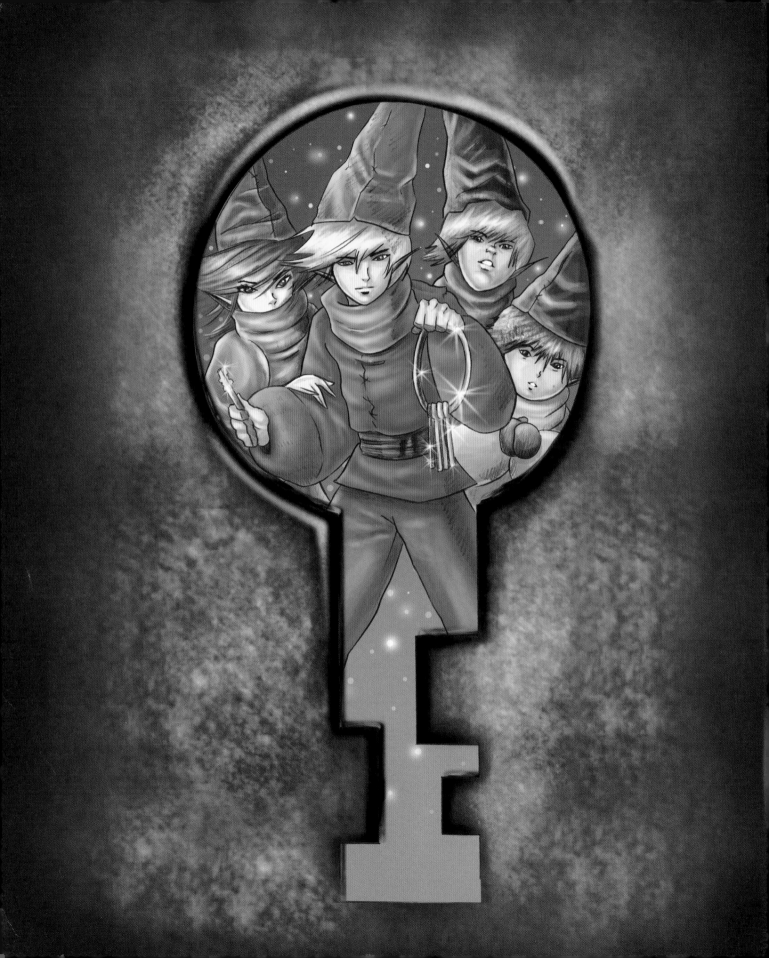

DRAWING FAERIES™
KEYS TO THE KINGDOM

CHRISTOPHER HART

WATSON-GUPTILL PUBLICATIONS/NEW YORK

Dedicated to my wonderful family: Francesca, Isabella, and Maria.

Executive Editor: Candace Raney
Editor: Anne McNamara
Designer: Mark Von Ulrich
Senior Production Manager: Ellen Greene
Color by MADA Design, Inc.

First published in 2006 by Watson-Guptill Publications,
a division of VNU Business Media, Inc.,
770 Broadway, New York, N.Y. 10003
www.wgpub.com

Hart, Christopher.
 Drawing faeries : keys to the kingdom / Christopher Hart.
 p. cm.
 ISBN-13: 978-0-8230-1408-8
 ISBN-10: 0-8230-1408-8
 1. Fairies in art. 2. Fantasy in art. 3. Drawing—Technique. I. Title.
 NC825.F22H38 2006
 743'.8939821—dc22
 2005033704

Manufactured in China

1 2 3 4 5 6 7 8 9 / 14 13 12 11 10 09 08 07 06

Special thanks to Anne McNamara, my editor, whose graceful touch is so appreciated. And to Ellen Greene, who pours her heart into
every project. Thanks to Candace Raney for believing in this book from the very beginning, and to Stan and the gang at MADA
Design for their expertise, and of course, the sweatshirts. And a very special thank you to all my readers who have made it possible
for me to bring a little bit of magic to your lives. You have brought some magic to mine.

Contents

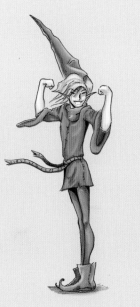

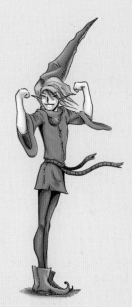

INTRODUCTION

Faeries belong to the realm of magic, halfway between the world of dreams and art. We may glimpse them through our imagination, and capture them with our pencils, pens, and brushes. The whereabouts of faeries is a closely guarded secret. Those of us who have actually seen them have been forced to swear an oath of silence. I am among the lucky few who have seen these enchanting beings firsthand, first as a child, then later as an adult. As an artist and trusted friend, I was allowed to capture the wonders I beheld in my sketchpad. In this book I will share with you, the reader, the secrets I have learned while drawing these fantastic beings. But first, to better help you to understand the true magic of the journey you are about to embark on, I must share with you how I most recently came to visit the inner sanctum of the faerie realm.

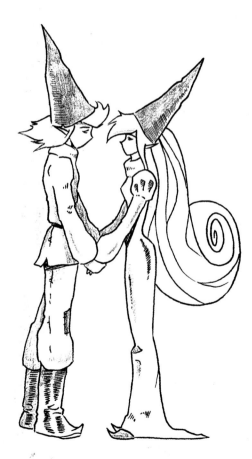

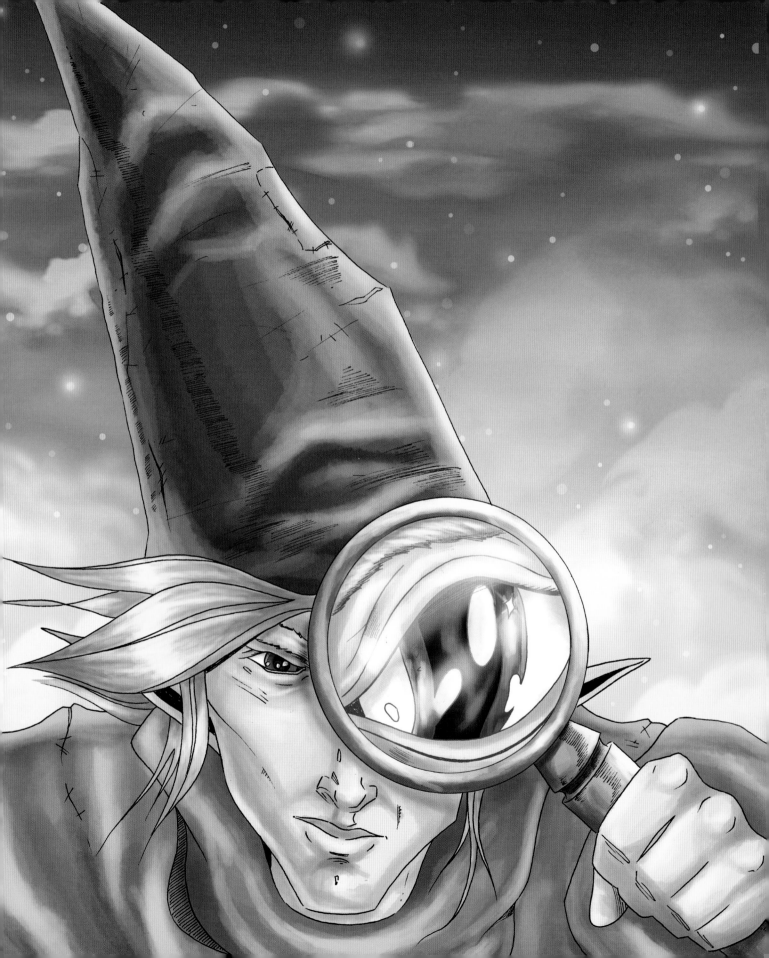

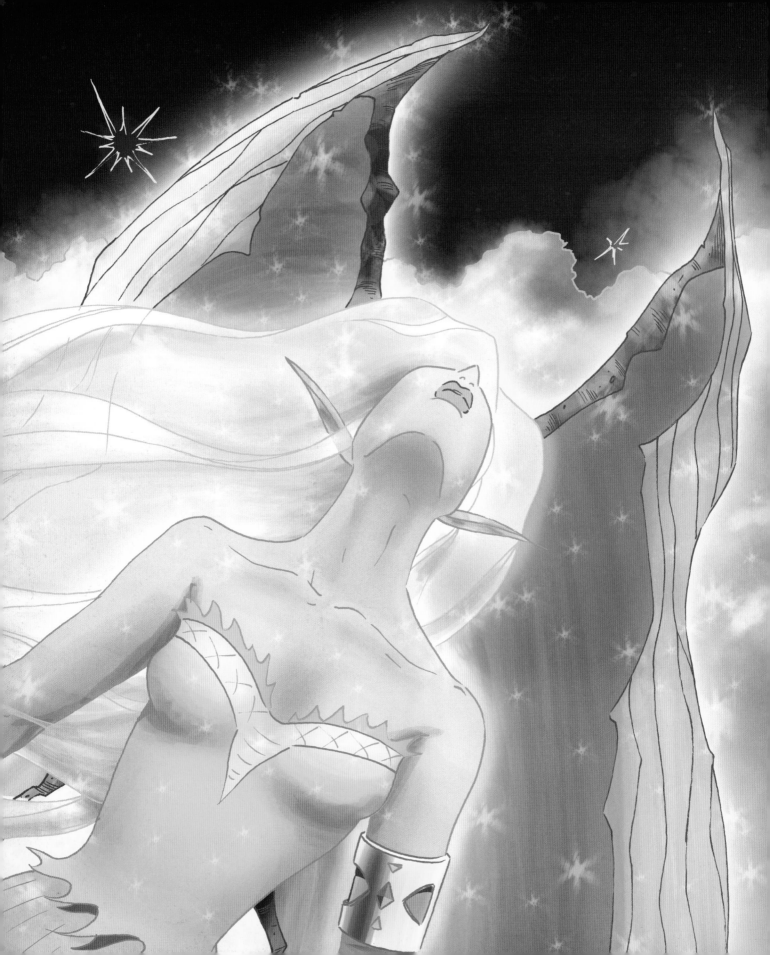

PART ONE

THE GATEWAY OF DREAMS

A Surprise Visit

I rarely remember my dreams, but I'll never forget this one as long as I live. Upon awakening, I had difficulty separating the true from the fanciful. Earlier that day, I had been struggling to illustrate a fantasy book for my publisher. After dinner I reviewed my work. It was technically all right, I suppose, but where was my inspiration? My pencil had been at work, but my imagination had taken a sabbatical. It was simply flat, and I was out of ideas. Already pressed up against a difficult deadline, I went to bed on the brink of despair.

After my eyes had been closed for some time, I was stirred by a vague sense of a soft, yet high-pitched voice whispering into my ear. That's how the dream began. I turned to the voice and was delighted to find my old friend Rollo Haavalhorn. Rollo is a tiny little elfin man, no bigger than your thumb—obviously faerie. I had first met Rollo in my youth, while living with my family in New England. It had been many years since our last visit, and I was elated to be seeing my old friend again. Rollo said that he needed a favor, and that I was the only one who could provide it.

Rollo shared that the King's daughter, a beautiful,
young princess named Ambrosia, was to be wed.
This was a cause for celebration throughout the
Faerie Kingdom. Everyone was preparing a
spectacular gift for the event. Rollo came up with
a wonderful idea for a present: he would give the
young couple a portrait. Not just an ordinary
wedding portrait, but a special image of love,
hope, and courage in the face of treachery and
danger. And my friend was asking me if I would
draw him such a portrait.

Princess Ambrosia

Naturally, I was intrigued, but I explained that I would have to see the subjects in order to draw
them. The idea of being able to catch sight of the entire Kingdom readying itself for a tremendous
celebration was exhilarating. But, sadly, Rollo broke it to me that I would not be able to visit the
Kingdom, due to my unfortunate "condition"—in other words, because I was human. Then how
was I to draw the portrait? I inquired, rather annoyed. I also did not understand what this
courage was that he wanted portrayed—in the face of what "dangers"? Rollo said he would
describe everything to me in this dream I was having, painting the sights with his words, so that
I, as an artist, would see them in my imagination. I consented, on the condition that I would be
allowed to use what I saw in the dream as inspiration for my book. After all, creative vision aside,
an author still needs to pay his bills. It was agreed.

 And so, following the soft sway of Rollo's voice, I traveled through the gateway of dreams,
back to the Faerie Kingdom…

Great Laws of the Faerie Kingdom

Once, every 600 years, the line of succession changes in the Kingdom, ushered in by a royal wedding. Following the exchange of rings and vows between bride and groom, the King hands the keys to the Kingdom over to the groom, who will then become the new Prince. This is a solemn ceremony, which carries great responsibility. The Prince will be the successor to the royal throne, the future King of the Faerie Kingdom.

The Royal Engagement

The Kingdom of Faerie is a wondrous place, filled with bliss and harmony. But not all would have it so; there are darker forces afoot. A royal nephew, Ulrich, had expected to marry the King's daughter, Princess Ambrosia. She was promised to him under the Laws of Succession in **The Great Book of Faerie**. But the Princess pleaded with her father, the King, to allow her to marry her true love, a peasant from the Lower Lands named Johan of the Arbor. The King put it to the Council of Elders to find some loophole in the law that would allow for such a break in tradition. A vote was cast. The results were divided, but thankfully the final count was in the Princess' favor.

And so it was done. The announcement was made that the Princess would marry her beloved Johan.

Johan of the Arbor

I was so captivated by Rollo's tale that I almost forgot to take note of our surroundings—we had suddenly reached the outskirts of the Kingdom. As I followed Rollo through the gates, I began sketching furiously on my pad. I was overwhelmed by what I saw—faeries in all sizes and shapes. I quickly began recording the faerie faces, bodies, gestures, and poses, analyzing anything and everything that made them so compelling to behold.

What follows are my drawings of what I saw on my dream journey through the Faerie Kingdom. I met many magical characters, and witnessed many extraordinary events. On several of my drawings, I made notes to myself to help me remember and reconstruct all of the wondrous things I observed. I think these visual notes may help you, too.

Faerie Basics

We visual artists are well versed in drawing humans, but are often at a loss when it comes to depicting other beings. As you can imagine, it's just not that easy finding models from a different realm. Because of this deficiency in our training, we are at a disadvantage when drawing faeries. That's why taking notes on my dream journey through the Faerie Kingdom was so important—so you, too, will be able to draw these enchanted beings.

The following pages from my sketchpad cover some of the essential traits and basic characters you'll encounter in the Kingdom. I've also included a few sketches of their magical friends so you can draw scenes depicting all of the inhabitants of the realm.

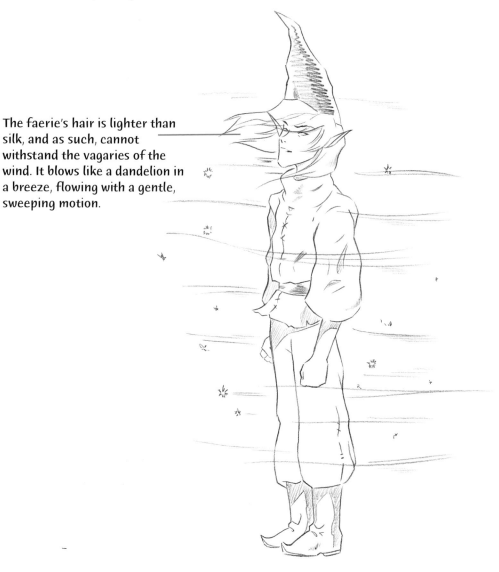

The faerie's hair is lighter than silk, and as such, cannot withstand the vagaries of the wind. It blows like a dandelion in a breeze, flowing with a gentle, sweeping motion.

Faerie Faces

There is nothing more delicate or wistful than the countenance of a faerie. The narrow, androgynous features accentuate its lightness of form. The faerie cheekbones are high, giving the cheeks a slightly sunken appearance. The most salient expression of a faerie is that of tranquility. Therefore, the eyelids rest comfortably on top of the pupils.

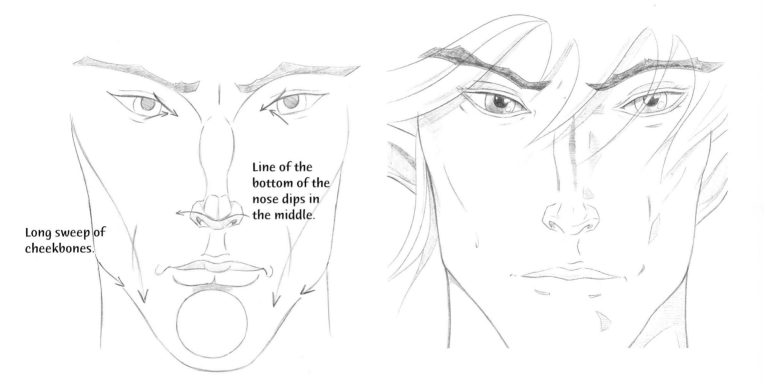

Line of the bottom of the nose dips in the middle.

Long sweep of cheekbones.

Contour Lines of the Face

Note the pleasant symmetry of the faerie face. It is unfettered by complexity. Faeries, even elders, do not have an abundance of lines and wrinkles. Those come from worry and frowns, alien to faeries.

Faeries are extremely forgetful about their worries, and must be reminded what it is they are to worry about. Unfortunately, no one remembers to remind them.

Young Male Faerie—Front View

This strapping young faerie will become a defender of the realm in a year or two. The confident glint in his eye, and a thick neck let us know that he is not of the winged variety. An earth-locked faerie, his labors and strength are invaluable to the security of the Kingdom.

Faerie Eye Diagram

A) Short line to tear duct
B) Short line to tear duct
C) Long sweep to crest of eye
D) Long sweep to outer edge
 of eyelash

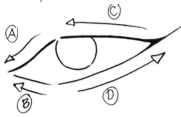

Human Eye

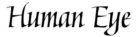

The human eye is rounder than the faerie eye, and "taller," if you will, at the midpoint.

Faerie Eye

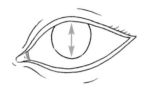

The faerie's eyelashes are thicker than the human's. Note how slender the faerie eye is—its predominant feature.

Ever-so-subtle indentation on side of face.

Contour of cheek.

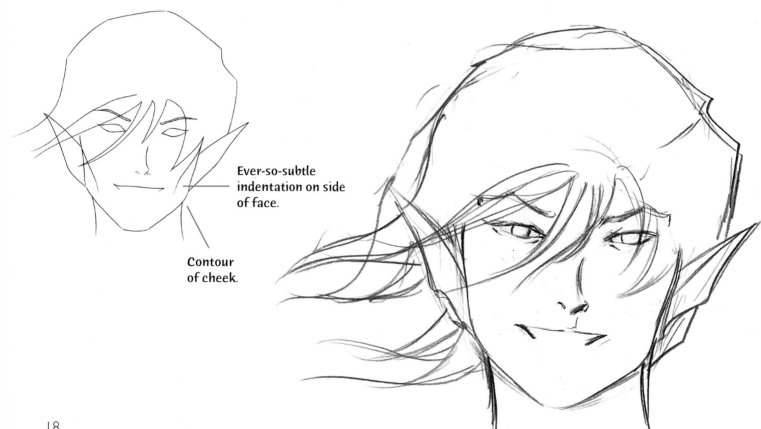

Young Female Faerie—Front View

Wanda has always known she had a gift. She could talk to the spirits of the storm, and they would tell her what their intention was. In this way, she saved the village from the Great Flood when she was just five. She is much beloved in the Kingdom.

Faerie Lips

Faerie lips do not always have the typical human "cupid's bow" indentation in the middle of the upper lip.

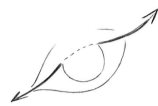

The eyelid is never drawn as a straight line across the eye, because the eyeball is round, and therefore, the eyelid must stretch to curve around it.

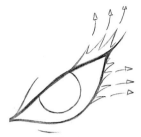

The upper eyelashes sweep up and away from the eye; the lower eyelashes sweep down and away from the eye.

Human Lips

Human lips always have the "cupid's bow" indentation in the middle of the upper lip.

The hair puffs up and doesn't lay flat on top of the head.

The chin indents slightly from the cheeks in the final version, giving the chin a delicate, discreet look.

19

The King's Magician

Most loyal of all of the King's subjects, and potentially the most powerful, is the court Magician. Only half faerie—the other half being from a faraway land—the Magician is utterly devoted to the King. Wise, but not ambitious; secretive, but not distrustful, the Magician has no patience for the bookish elders of the Council of Faerie. With half-concealed amusement, the King has often been forced to listen to the complaints of the elders who take note of the disrespect the Magician has given them and their high office, especially when they cite the rules and regulations that he continues to flout. The King always promises to speak to the Magician about it. And he may, someday.

Smallish head cap area.

Sizeable eyebags.

Long secondary crease.

Very pronounced cheekbones.

Cheeks sink deep into face.

Age and gravity cause jowls to hang.

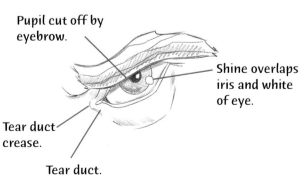

Pupil cut off by eyebrow.

Shine overlaps iris and white of eye.

Tear duct crease.

Tear duct.

The Faerie King

Throughout history, kings have been described as many things. There have been conquerors, imbeciles, cowards, intellectuals, and even lunatics. But the King of the faeries stands above them all, for only he, and he alone, is so humble and kindhearted that he is described as "The Grateful King."

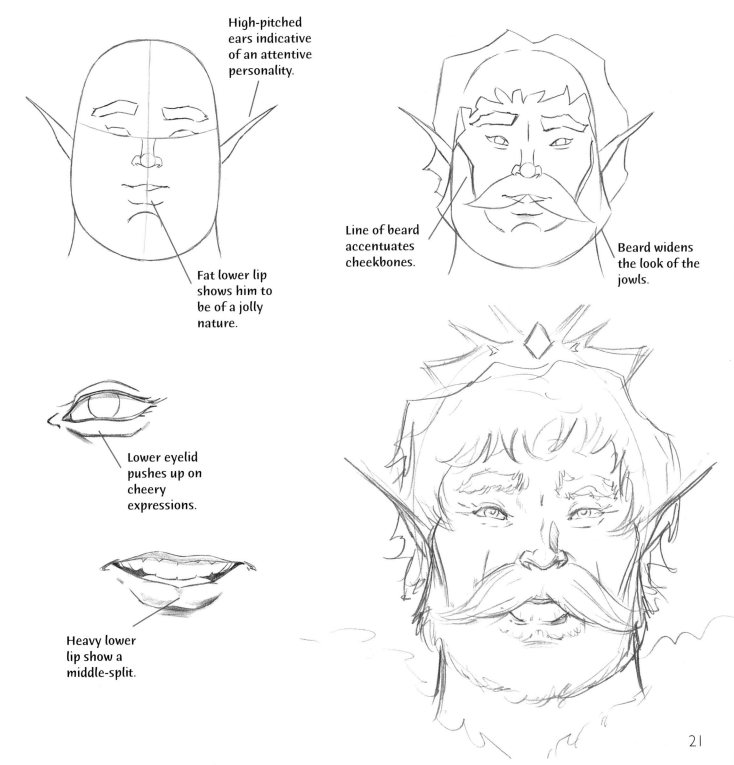

High-pitched ears indicative of an attentive personality.

Fat lower lip shows him to be of a jolly nature.

Line of beard accentuates cheekbones.

Beard widens the look of the jowls.

Lower eyelid pushes up on cheery expressions.

Heavy lower lip show a middle-split.

The Graceful Neck of the Faerie

This faerie from the east meadow has had to let her true love go. It is his turn to leave the village to find the herbs that will preserve the food stores during the long winter months. It is an arduous journey to the other side of Dark Mountain, and will take a month's time, round trip. Not all who have gone return. But the task is necessary for the survival of the Kingdom.

Main neck muscle

Minor neck muscle

Extended shoulder-muscle

Collar bone

Village Youth

Peter is only 200 years old, and already a pretty good marksman with an arrow. Today, he is dressed in his Sunday best, the outfit he will wear when he lights the candles at the wedding ceremony. People like Peter. He's a dreamy adolescent. He hopes to one day sprout wings and fly. Most of the elders doubt he ever will. He's about twenty years past the age. Nevertheless, his mother is still hoping. A few of the girls hope Peter will give up on the flying idea and pay more attention to them.

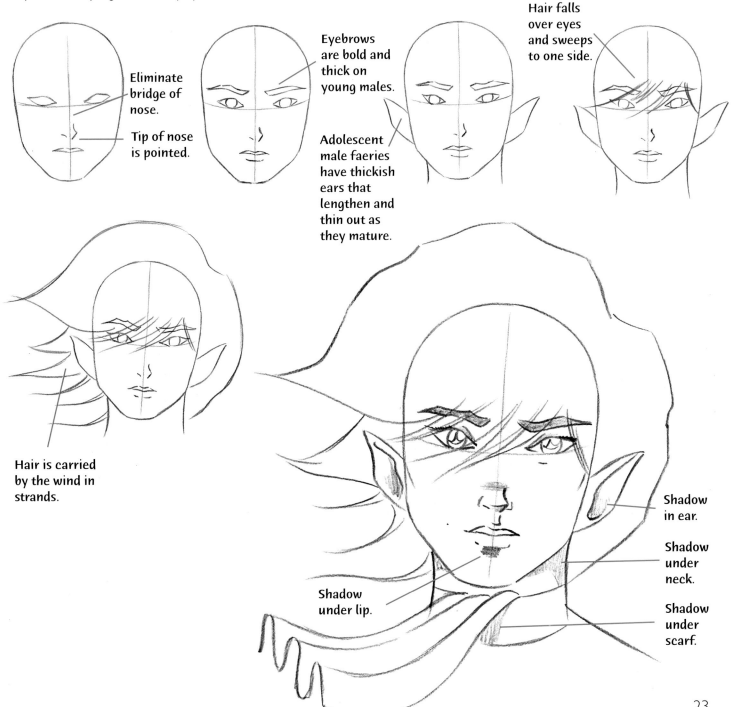

Eliminate bridge of nose.

Tip of nose is pointed.

Eyebrows are bold and thick on young males.

Adolescent male faeries have thickish ears that lengthen and thin out as they mature.

Hair falls over eyes and sweeps to one side.

Hair is carried by the wind in strands.

Shadow in ear.

Shadow under neck.

Shadow under scarf.

Shadow under lip.

23

The Faerie Profile

The great thing about sketching your subject in a dream is that he can't see you. Therefore, you can get a candid and extended look at him. This is the King's covetous nephew, Ulrich, in an unguarded moment. As Rollo put it, "Any kindness was lost on him." Ulrich begged the king to prepare him for a higher rank through weapons training and greater access to the forbidden books of faerie. But the King offered only to bring Ulrich along with him on his weekly visits to assist the sick. Ulrich would have none of it and stormed off in disgust. What Ulrich did not realize was that that was precisely how the King prepares his nobles for greater responsibilities.

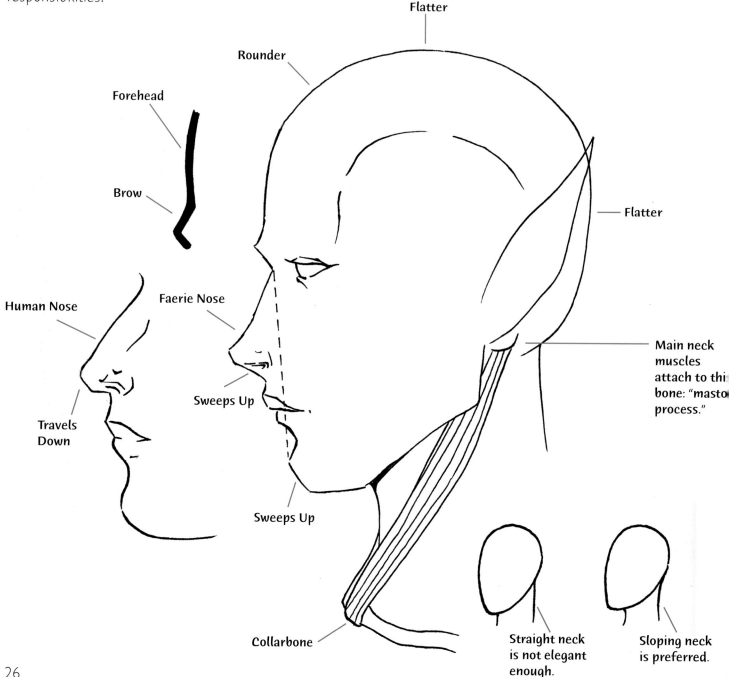

Flatter

Rounder

Forehead

Brow

Flatter

Human Nose

Faerie Nose

Main neck muscles attach to this bone: "mastoid process."

Sweeps Up

Travels Down

Sweeps Up

Collarbone

Straight neck is not elegant enough.

Sloping neck is preferred.

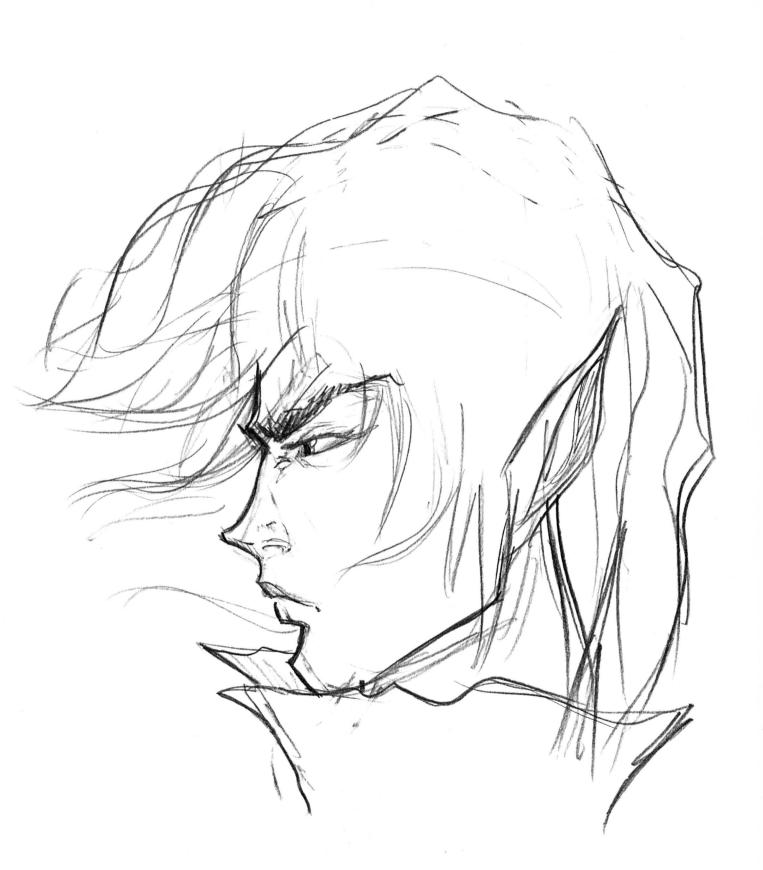

Comparing Male & Female Faerie Faces

The outline of the female face softens her look and significantly add to her attractiveness, while the male face accentuates strong, sleek bone lines.

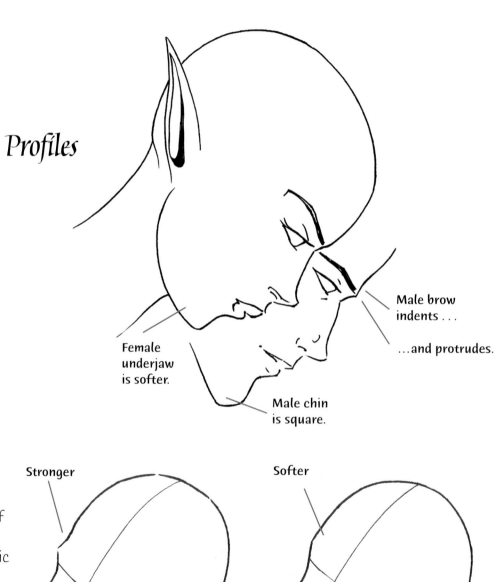

Profiles

Female underjaw is softer.

Male chin is square.

Male brow indents . . .

. . . and protrudes.

3/4 Views

Subtle differences in the outline of the face can be seen in the 3/4 view as well as the profile. Strategic softening results in a feminine look.

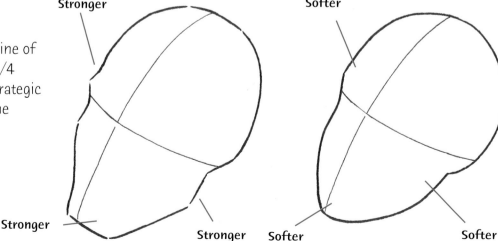

Stronger

Stronger

Stronger

Softer

Softer

Softer

A Profile Portrait in Pencil

A.
This pose begins with a head bowed at a significant angle. The thing that makes profiles convincing, which many artists forget, is to add enough mass to the back of the head. Without enough mass, the head appears flat, which is unappealing.

B.
Next I begin to carve out the features in the front of the face, much as a sculptor would. I begin by indicating where the brow and the bridge of the nose meet, because they wedge together nicely at the eye-line. It's a convergence of three elements—a good place to start; eye, brow, and bridge of nose.

C.
The chin sweeps upward, dramatically.

D.
The eyebrow is placed at the crest of the brow. It is drawn high-to-low, meaning that it starts out high, then descends as it travels toward the bridge of the nose.

E.
The nostril and the lips are filled in at this point, after the basic structure is in place. Once I get to this point, I begin to draw over some of the lines that I like, pressing just a bit harder, in order to make them stand out, and erasing some of the initial guidelines.

F.
Then I begin the process of lightly adding shadow for accent. Shadow, even just a touch of it, adds a feeling of three-dimensions that a purely black-and-white picture cannot hope to achieve.

A Simple Tilt of the Head

Faeries are lyrical beings. Their bodies are like vessels through which emotions travel unfettered by the anxiety of the modern human condition. A faerie never glances sideways out of the corner of his eye. Rather, he fully tilts his head back in wonder to gaze up at a starry night. Other times he may look straight ahead with perseverance and resoluteness. Or, his head may fall, either in reflection or melancholy.

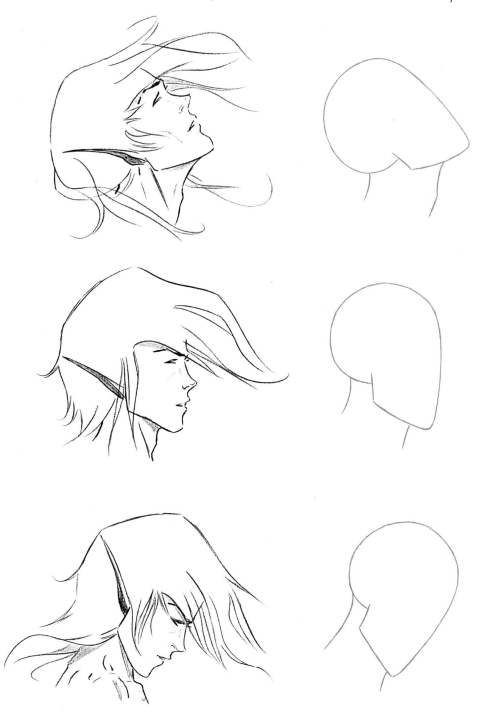

The Three-Quarter View

The slender nature of the faerie face is never more in evidence than in the three-quarter view. The tricky part, for most people, lies in drawing the nose at this particular angle, because of the way it sticks out from the face. It also requires one to draw a good deal of the underside of the nose, which is rather uneven, in that you don't always see both nostrils. Yet the three-quarter view is a beautiful angle for artists, because it so clearly emphasizes the head as a solid, three-dimensional surface with graceful contours that trail off at the far side of the face. The area of the head that I've shaded demonstrates the near plane of the face.

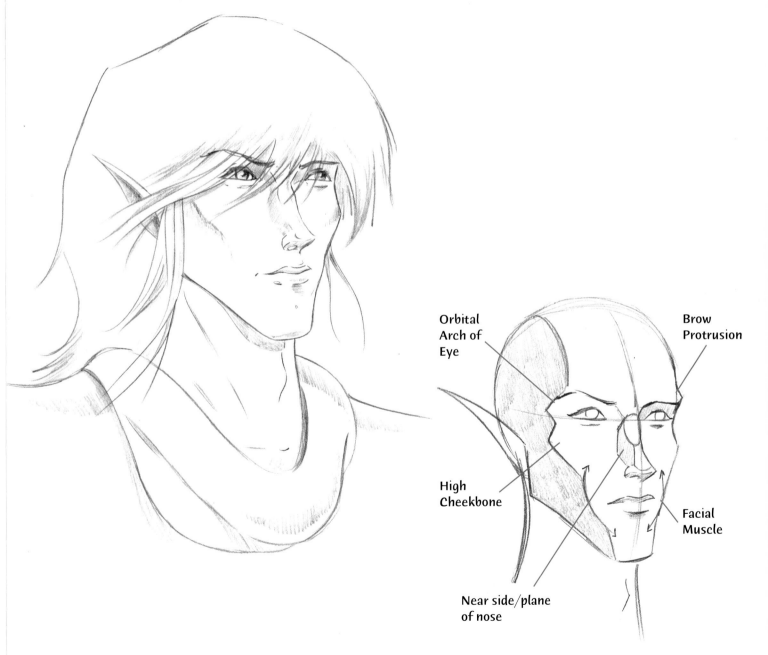

Orbital Arch of Eye

Brow Protrusion

High Cheekbone

Facial Muscle

Near side/plane of nose

31

The Faerie Body

Now that we've covered the basics of drawing faerie faces, let's move on to drawing the faerie body, which will allow us to complete the characters. While we'll still draw some head poses of faeries we come across, we'll mostly be drawing full body poses from this point on.

Gesture Poses

What are gesture poses? Unlike life drawing studies, where the model sits in a static pose for ten to thirty minutes, a gesture pose is a very quickly drawn "impression" of the general feeling or flow of a pose, taking no more than two minutes to complete. It gets right to the essence of the stance. No features need be drawn on the face. Some beautiful gesture poses have been drawn with only two lines. Sketching gesture poses is excellent practice for visual artists, as it forces you to leave out all extraneous devices and tricks, and concentrate only on the spirit of the subject matter. Here are some gesture sketches of faeries in typical, playful poses. You might like to try your hand at copying some of these, to get out of the bad habit of only drawing humans.

Human bodies are not nearly as limber, lithe, or expressive as faerie bodies. In fact, the body of the faerie is even more expressive than the face! This is the opposite of the human condition. The human face can smile and laugh, while the body sits stationary on the couch for hours, facing a wide-screen TV.

Body Types

It's a common misunderstanding that "faerie" is a specific term. It is not; it is a generic term. There are different types of faeries, as anyone who has spent any time around them will know at once. A faerie fighter can no more fly than you or I. And a faerie in flight has no more brute strength than a butterfly. They are different sorts, but both are necessary to the Kingdom. Each type of faerie is drawn differently by the artist. Let's begin with the faerie fighter.

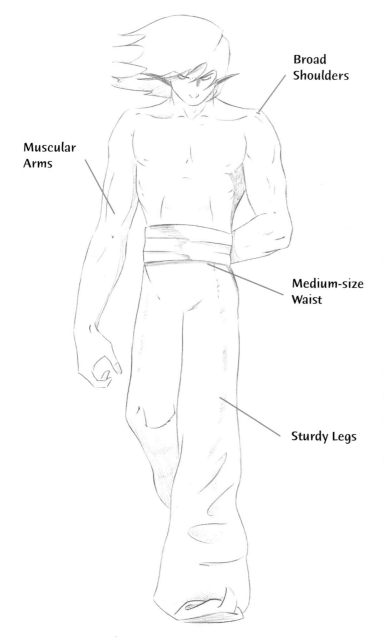

Broad Shoulders

Muscular Arms

Medium-size Waist

Sturdy Legs

The Faerie Fighter

The faerie fighter is of a sturdier build than others you might have seen. Humans erroneously think of faeries as being uniformly light and airy, when in reality there is a significant number that are rugged and strong. In fact, the survival of the Kingdom depends upon such individuals, without whom, all would perish.

The defender of the realm is powerfully built. His courage and forthrightness is apparent in the way he walks. There is no guile. His movements are not quick, nor are they nimble. Rather, he moves purposefully, solid and strong, yet still graceful.

Anatomy of a Faerie Fighter

The faerie fighter must be capable of wielding the heaviest of weapons: the two-handed sword. This thickly boned faerie's skeletal structure is identical to that of humans, in that his forearms have two bones: the ulna and the radius. Likewise, his lower legs have two bones: the tibia and the fibula. These give his limbs the power he needs.

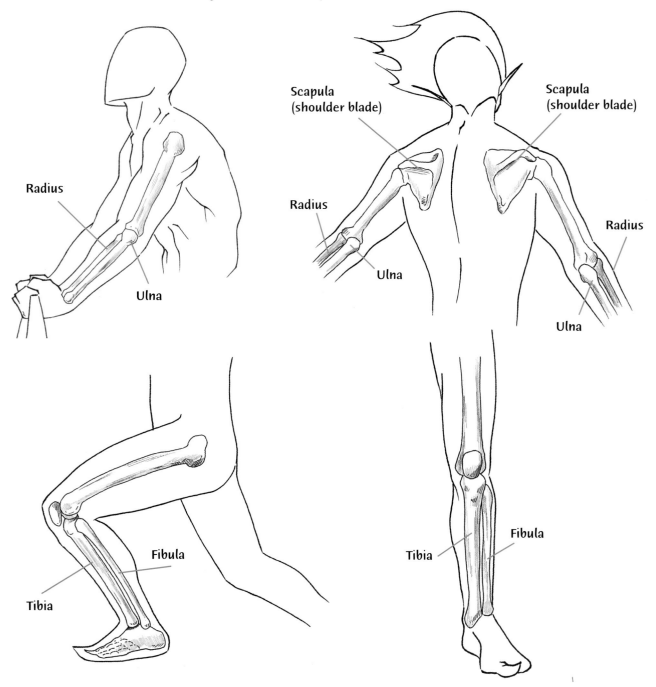

Female Faerie Fighter

Female fighters use their considerable skills to learn the ways of the warrior. Shava has the eye of an eagle. With an arrow, she can sever a rose from its stem from over 100 yards away. Shava did not choose this path, she was born to it. She comes from a long line of warrior women devoted to preserving the safety and longevity of the Kingdom.

Female fighters have strong, compact physiques. Like their male counterparts, they have two bones in their lower legs and forearms which add to their strength and solidity. They are not fliers, but can run and leap as fast as the wind.

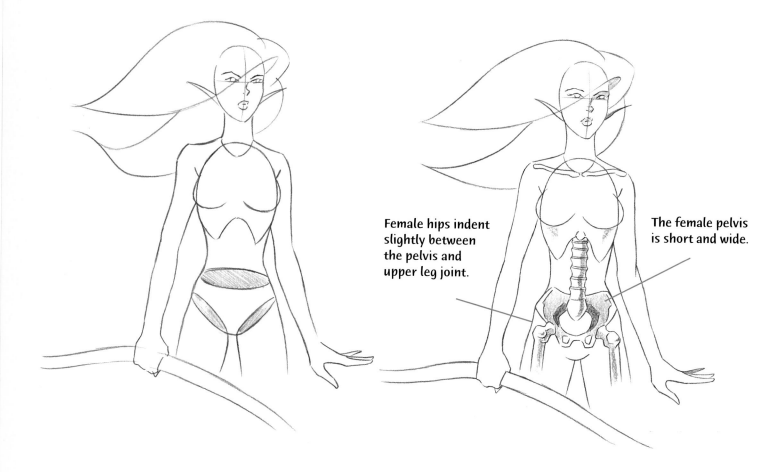

Female hips indent slightly between the pelvis and upper leg joint.

The female pelvis is short and wide.

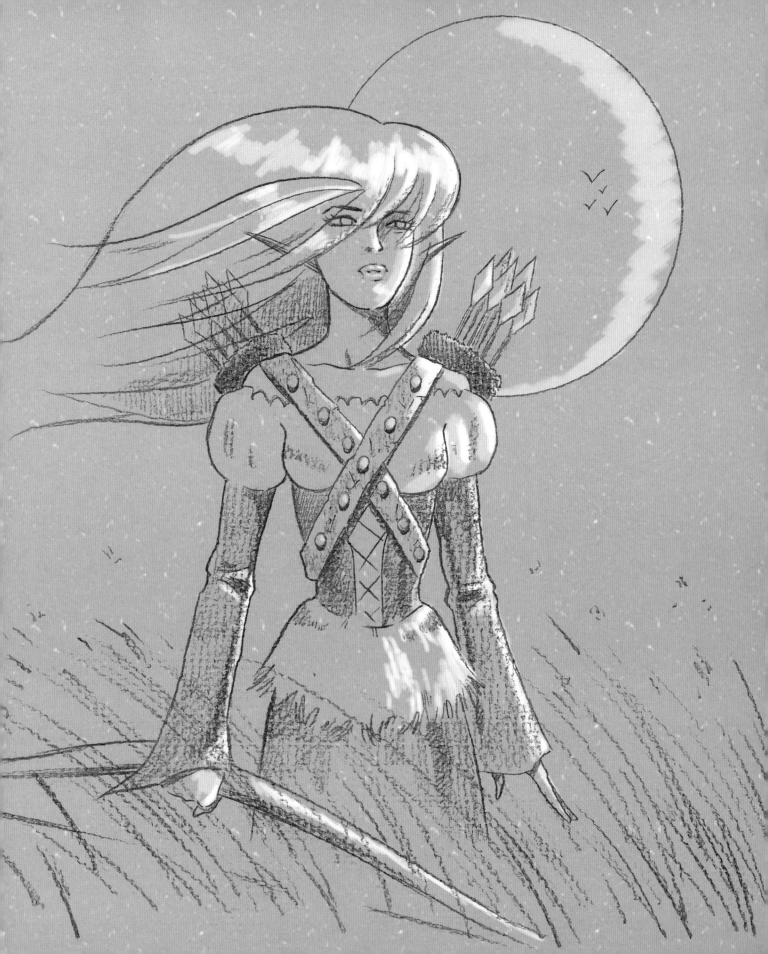

Maja of the Mountain

Maja is a light-boned female faerie, the tiniest and most delicate of all faerie types. Faeries of this sort are such small creatures that they have no pets with which to play. There simply are no creatures tiny enough. So Maja uses magic to create her own pets from sparkles in the air. Although these pets only last a few hours before they vanish back from which they came, they do seem to enjoy their short visits to the mountain.

Notice how the female body, quite different from the male, overcompensates as each section tilts in one direction, and then in the other, as indicated by the arrows. The more attractive the female character is, the more noticeable the compensation may be drawn.

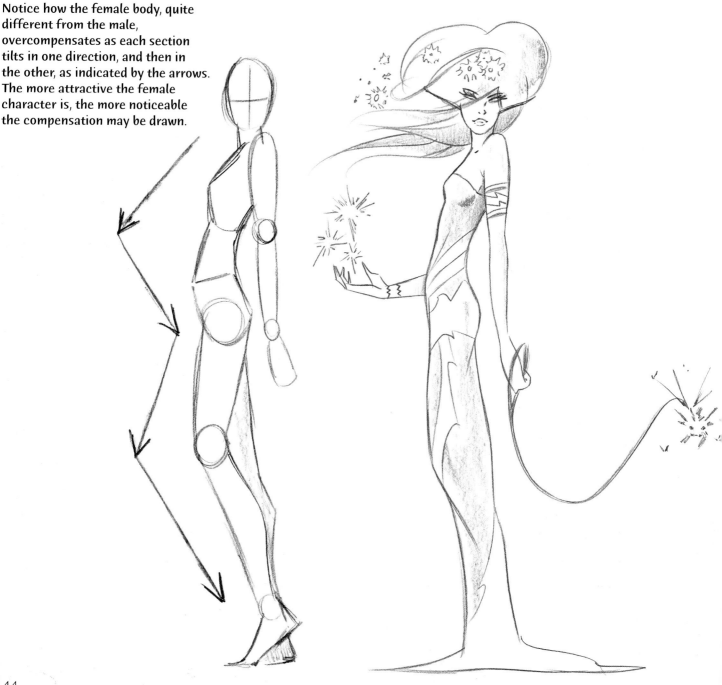

Princess Ambrosia

Princess Ambrosia is a winged faerie with the heart and mind of a warrior. She can move swiftly on the ground as needed, wings folded gracefully behind her back. But when circumstance or desire call her to flight, her wings gloriously unfold.

A Ride Outside the Castle Walls

The spirit cannot be confined to a gilded cage, not even to a royal one. The Princess disregards all danger and enjoys a daily ride outside of the confines of the castle on her beloved Thunderbolt. It is dangerous, indeed, for the Princess to be unguarded during these perilous times. However, she is by far the best rider in the Kingdom. Several of Ulrich's red knights have collapsed with broken hearts while trying to keep up with the Princess and Thunderbolt on a dead run through the valley.

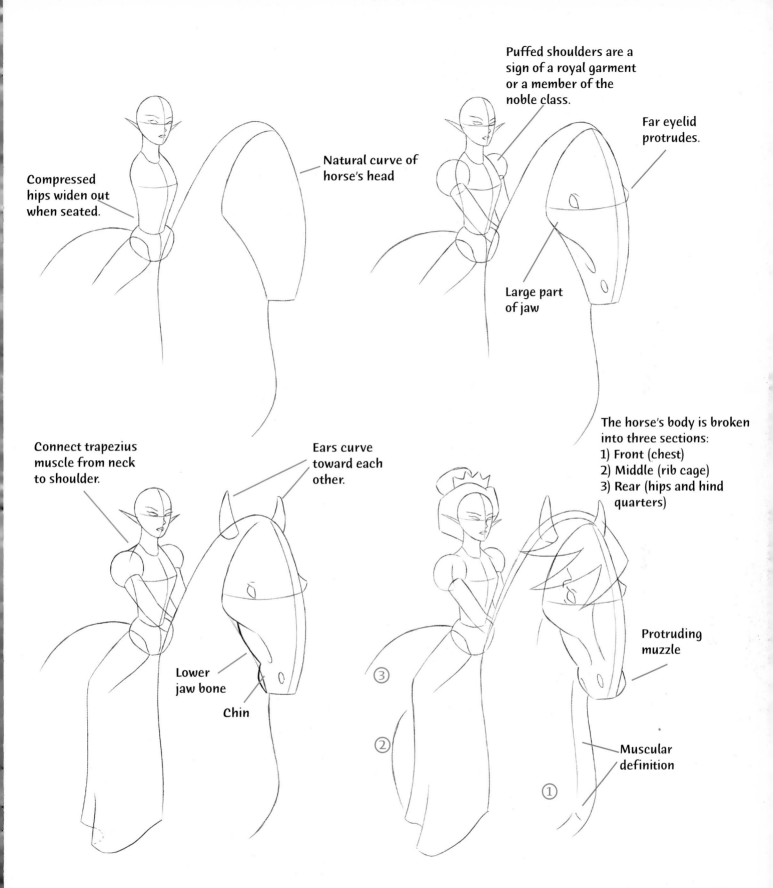

Compressed hips widen out when seated.

Natural curve of horse's head

Puffed shoulders are a sign of a royal garment or a member of the noble class.

Far eyelid protrudes.

Large part of jaw

Connect trapezius muscle from neck to shoulder.

Ears curve toward each other.

Lower jaw bone

Chin

The horse's body is broken into three sections:
1) Front (chest)
2) Middle (rib cage)
3) Rear (hips and hind quarters)

Protruding muzzle

Muscular definition

The Making of the Keys

Ulrich was enraged at being bested by the Princess' lover, whom he scornfully referred to as the "peasant prince." On the day the upcoming wedding was announced, Ulrich mounted a violent coup to seize the Kingdom for his own. Buildings were destroyed, houses were sacked, and villages were torn apart. Ulrich and his army would have succeeded, save for a few brave knights loyal to the King. Ulrich was captured and imprisoned, where he waited trial for his crimes.

But with help from his treasonous band of followers, Ulrich escaped and fled to the Land of Darkness, Noroon, where he built a fortress kingdom of his own. There, he began to amass a stronghold of well-armed men, never wavering in his desire to avenge his defeat and capture the Princess, the Kingdom, and all of its riches.

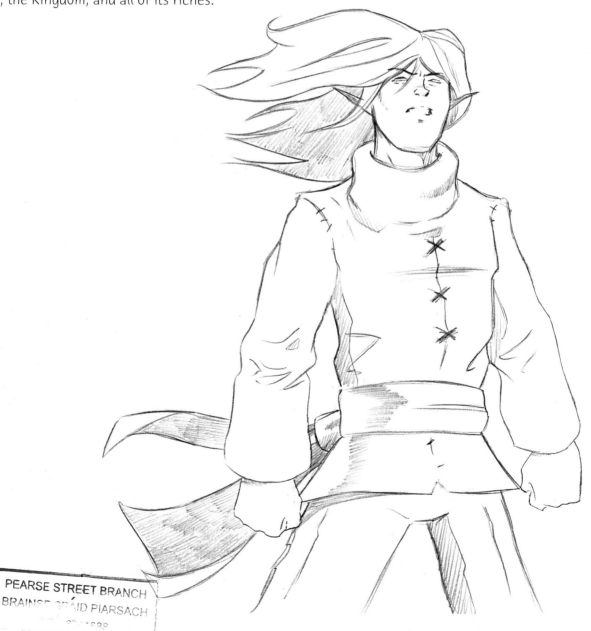

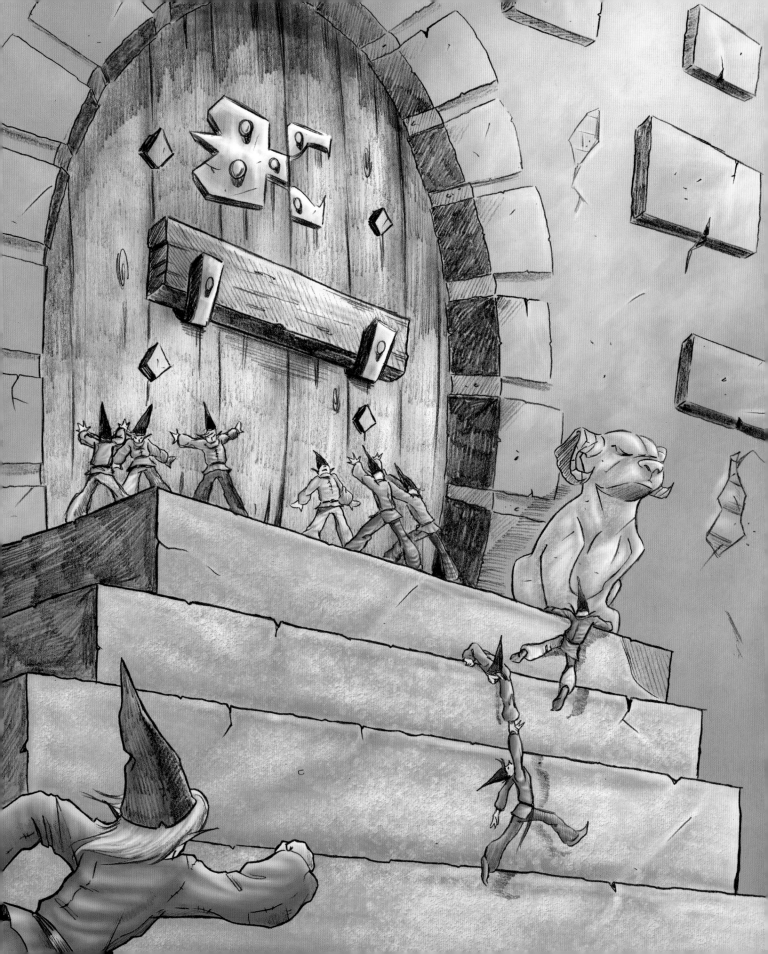

As soon as the tensions erupted, the King called on the Master Blacksmith—who was, coincidentally, my friend Rollo—to create a series of impenetrable locks and a special set of keys to safeguard every part of the Kingdom. If Ulrich were to get his hands on the keys to the Kingdom, all would be lost.

Rollo set off to create the strongest locks in the land. There would be a lock for each gate guarding access to the Kingdom, as well as a lock on the doors and entranceways to all of the sacred places within the Kingdom's borders.

When Rollo finished with his arduous task, he set out on a tour of the castle and its grounds, testing out each and every lock and key.

I was invited to follow, to observe, and to draw what I saw.

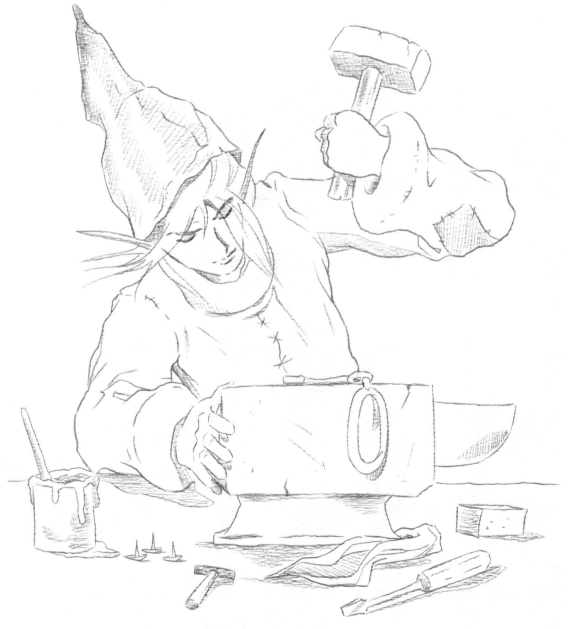

One of the important keys to the Kingdom unlocks the stockade, where Ulrich, the King's ruthless and ambitious nephew, was segregated after his violent, and nearly successful, coup. Before the special locks and keys were created, loyalists to Ulrich were able to engineer his escape, and ferreted him out of the kingdom under cloak of darkness in the undercarriage of a water wagon.

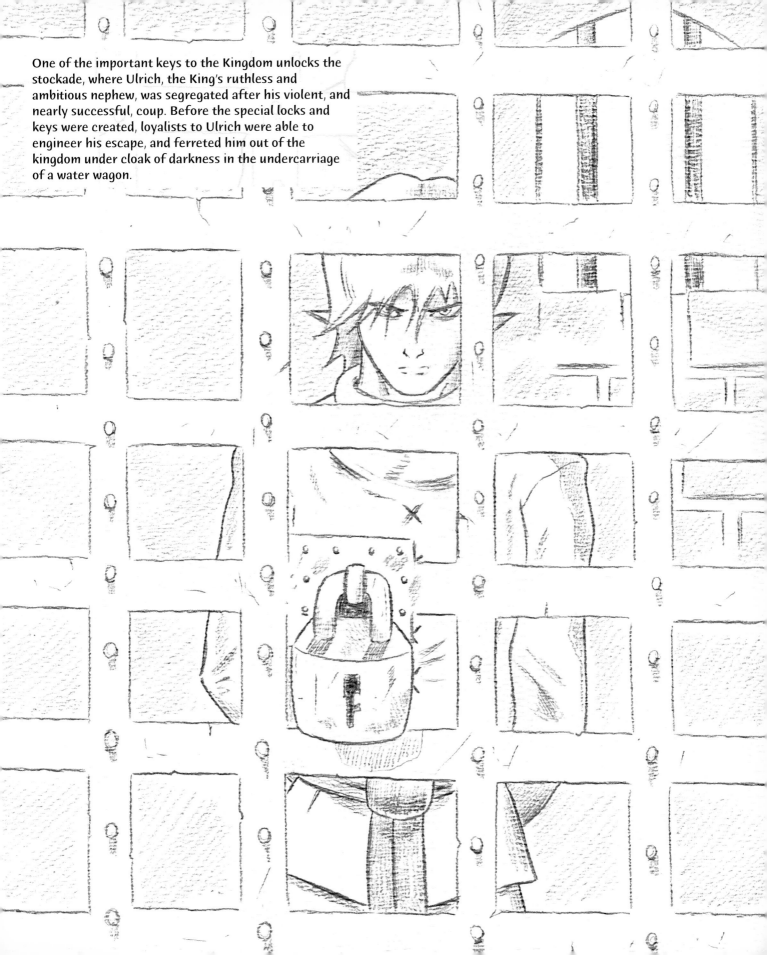

Securing the Kingdom

Once Johan is crowned as the new Prince, Rollo will escort him through the Kingdom to instruct him on the workings of the keys. It is the Prince's obligation to memorize which keys belong to each lock. There will eventually be 132 keys in all. The Prince will hold their knowledge within his heart. The fate of the Faerie Kingdom rests on his shoulders.

The first key unlocks the Room of Anguish. In it, there is a small vial of poison, which the king will drink if he fears he is in imminent danger of being captured by evil forces. For the people so love their king, that were he held hostage they would do anything in order to win his release. And a king must so love his people that he would never allow that to happen.

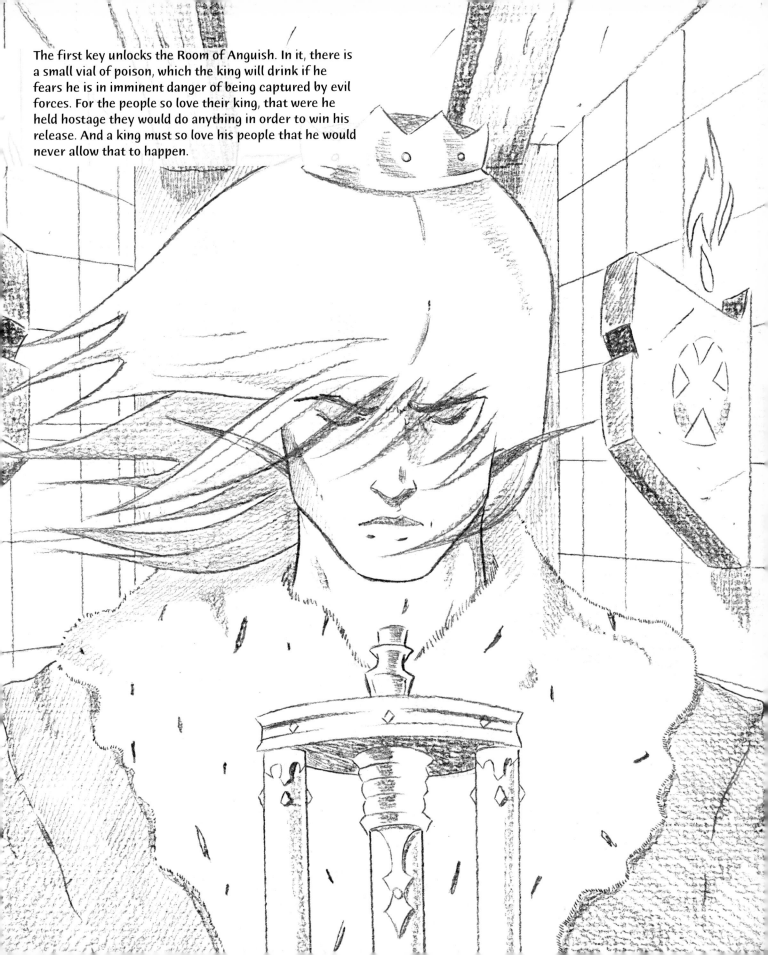

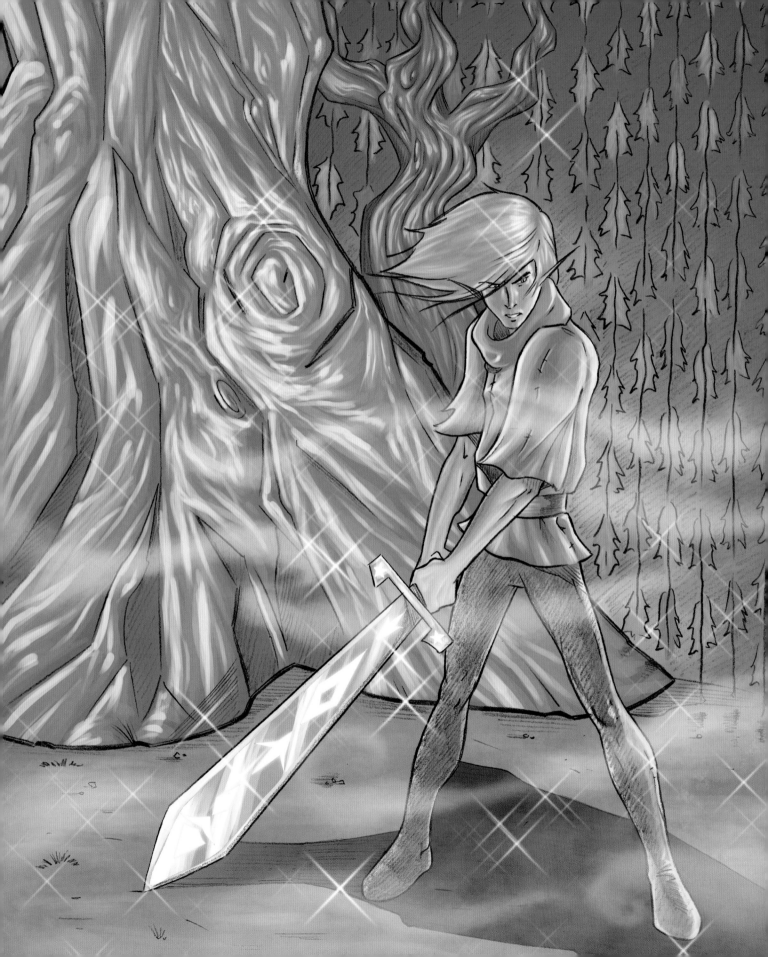

The Master Swordsman

Despite their diminutive size, faeries can be fierce warriors, especially when their homes and loved ones are threatened. The Master Swordsman practices his skills daily and is always ready to protect the Kingdom.

Drawing the Body

The visual notes I've jotted down here are based on simplified anatomical principles, which provide easy reference points for drawing the body. I think you'll find them useful.

Dynamics of the Body

Dynamic concepts help in adding drama to a pose as well as increasing visual excitement and tension.

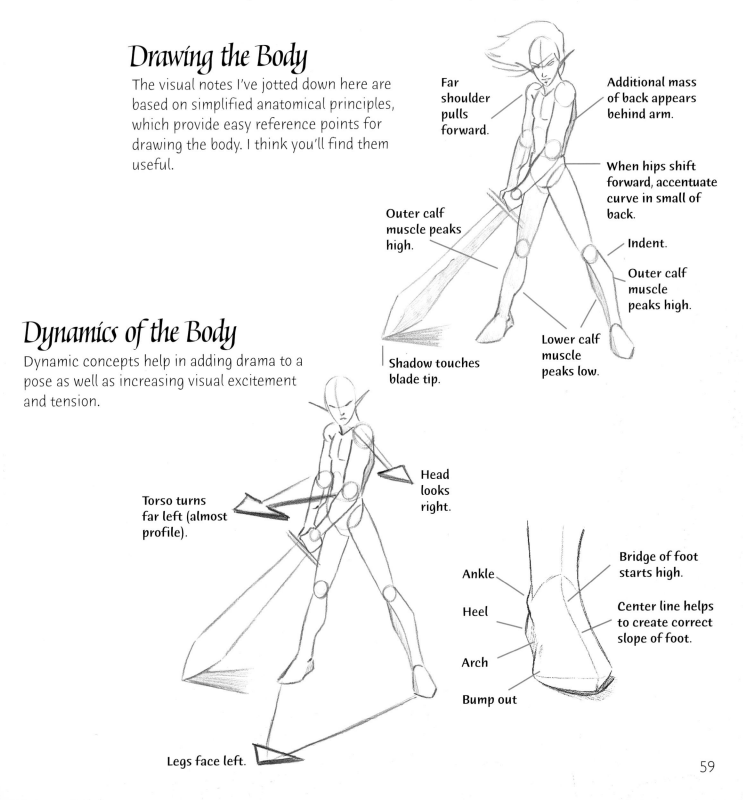

Far shoulder pulls forward.

Additional mass of back appears behind arm.

When hips shift forward, accentuate curve in small of back.

Indent.

Outer calf muscle peaks high.

Outer calf muscle peaks high.

Lower calf muscle peaks low.

Shadow touches blade tip.

Head looks right.

Torso turns far left (almost profile).

Ankle

Heel

Arch

Bump out

Bridge of foot starts high.

Center line helps to create correct slope of foot.

Legs face left.

Ready Position—Blade Fighter

The sword is too heavy to be picked up and swung as a sudden response to danger. The fighter must begin with the sword held up high, in the ready position. The arms are pulled back, coiling with pent up energy. When released, the weight of the blade carries it to ever increasing speeds so that it swings faster at the end of its stroke than at the beginning.

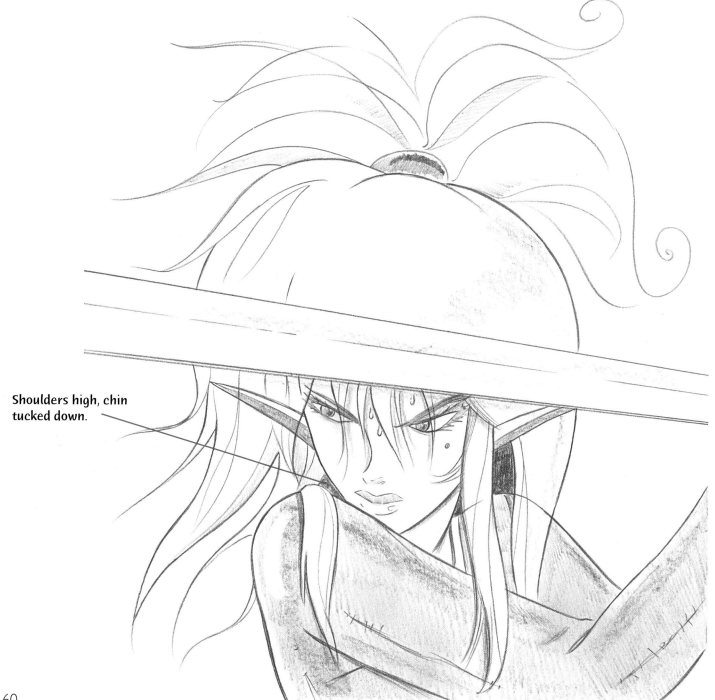

Shoulders high, chin tucked down.

The guidelines show this face tilting upward.

Upward Look in Fighting Pose

Looking up in a fighting pose makes a character appear weak and wavering.

The guidelines on the face show that the face is tilted downward.

Downward Look in Fighting Pose

A downward tilt of the head, which causes the character to glance up past her eyebrows, gives an unmistakable look of determination and bravery.

Only a True Heart Can Pierce the Darkness

It takes a pure soul to look into the heart of evil and remain undeterred. Therefore, the Archer's mind's eye must be keener and sharper than the tip of his arrow. A moment's hesitation, and his thoughts would be consumed in the eye of the dragon. Nothing is more lethal than the Archer's arrow, for every creature, no matter how great, has its soft underbelly.

The Hypnotic Spell of Jewels

Echo is an elfin faerie—a tiny man of a faerie, who has the perennial look of a boy. Echo has, unfortunately, fallen under the spell of jewels, and has lost interest in all other things. Their beauty puts him in a trance, and nobody can seem to bring him out of it. But it hurts no one, really, and he has become quite the expert in identifying various gems.

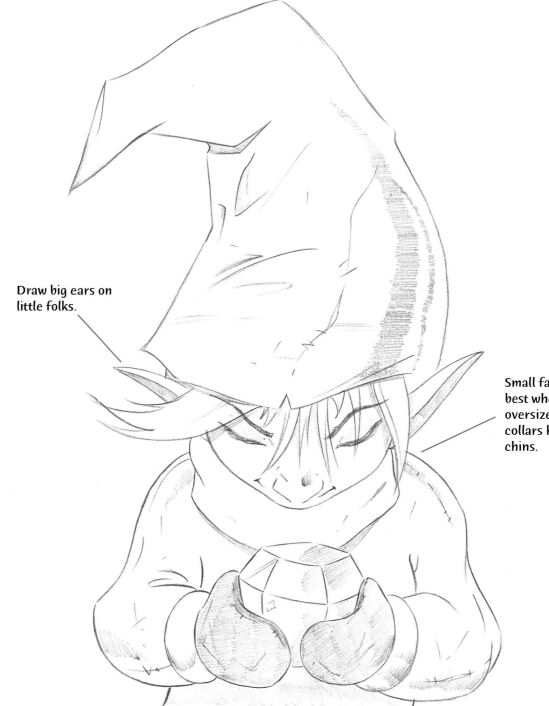

Draw big ears on little folks.

Small faeries look best when drawn with oversized turtleneck collars hiding their chins.

Drawing the Eye at Different Angles

When a faerie, or even a human, looks up or down, the shape of the eye changes, at least the way we draw it does, due to slight variations in perspective. Without these minor adjustments, no drawing can maintain the gracefulness that a tilt of the head is meant to convey. There are three main eye positions (see illustrations along bottom of page): looking up (1), looking out (2), and looking down (3). But there are a few subtler steps in between, as noted in the smaller drawings directly below (labeled A through E).

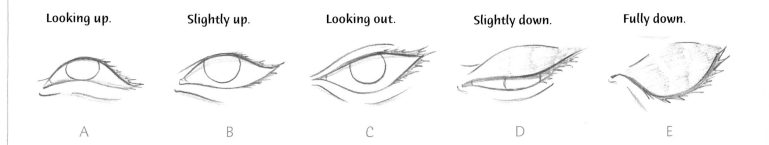

| **Looking up.** | **Slightly up.** | **Looking out.** | **Slightly down.** | **Fully down.** |
| A | B | C | D | E |

Curve of the Eyebrows

Just as the eye changes shape when the angle shifts, likewise, the eyebrow changes direction. I've used bold arrows to indicate this shift.

1) Upward looking eyes have a high arching eyebrow.

2) Neutral eyes take a medium arching eyebrow.

3) Downward cast eyes take a downward sloping eyebrow that actually curves *toward* the eye, with very little room between the eyebrow and the eye itself.

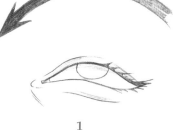

1

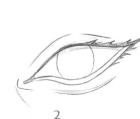

2

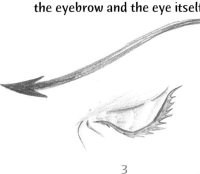

3

After School Activities

Every year, a new batch of youngsters "discovers" the roof as a launching pad, not realizing that it has been used that way by every class for the past 800 years. The elders are aware of this little mischief, but don't let on. And why should they? They began the tradition when they were kids!

Maybe Next Year, Little One

Faerie wings don't all grow at the same rate, as this little faerie knows. She's sad because she was told she would have to wait a bit longer before she can attend flight school. You know how kids are. They get very self-conscious about these things. But they simply cannot be allowed to fly before their wings reach a certain length. It's for their own good, although try and get them to see that!

Natasha

Natasha is the princess of the flower garden...well, she's not actually a princess. She just grew up being called "princess" so often by her adoring father that she ended up believing it. Her father didn't have the heart to break it to her, so he petitioned the King, who gave her the honorary title of "Princess of the Garden," even though there really isn't any such title. She is particularly proud of the hat.

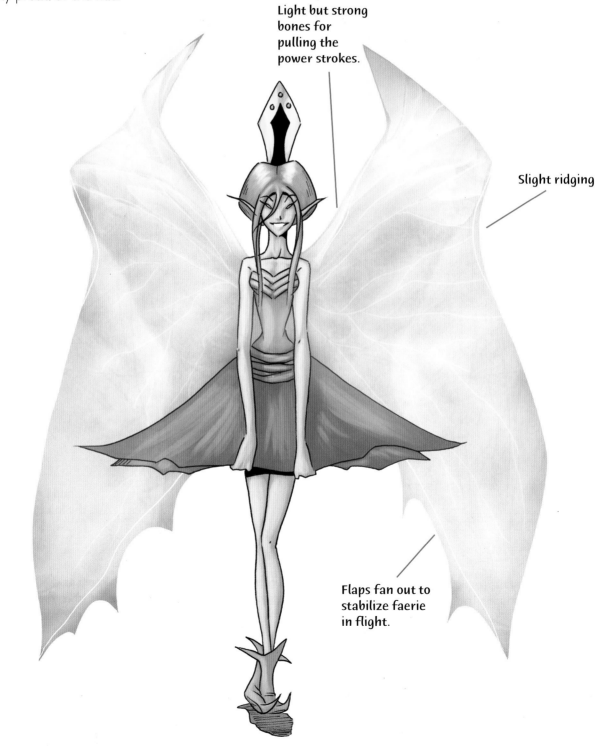

Light but strong bones for pulling the power strokes.

Slight ridging

Flaps fan out to stabilize faerie in flight.

Correct Placement of the Wings

When drawing a set of wings with the character facing forward, the point at which the wings attach to the body is, obviously, obscured. So it is important to lightly sketch *through* the figure to the place on the upper back—always the upper back—where the wings attach. That will help you arrive at the correct placement. If you do not do this, you may end up drawing wings that at first look correct, but if carried to their logical conclusion, actually attach to the faerie's neck and bottom, a most unfortunate situation for any faerie, indeed.

Correctly Placed

The dotted lines may be erased once the wings are completed. I have only used them as a guide.

Incorrectly Placed

Wings & Landing

When a faerie lands, the wings must gather tightly together in back, for were they to remain spread, they could catch an unexpected gust of wind and send the faerie airborne again. All limbs are extended as he reaches for the ground.

Narrows at the waist.

A long, straight line creates an elegant look.

Compression forces calf muscle to "bunch up."

They lose more hats this way!

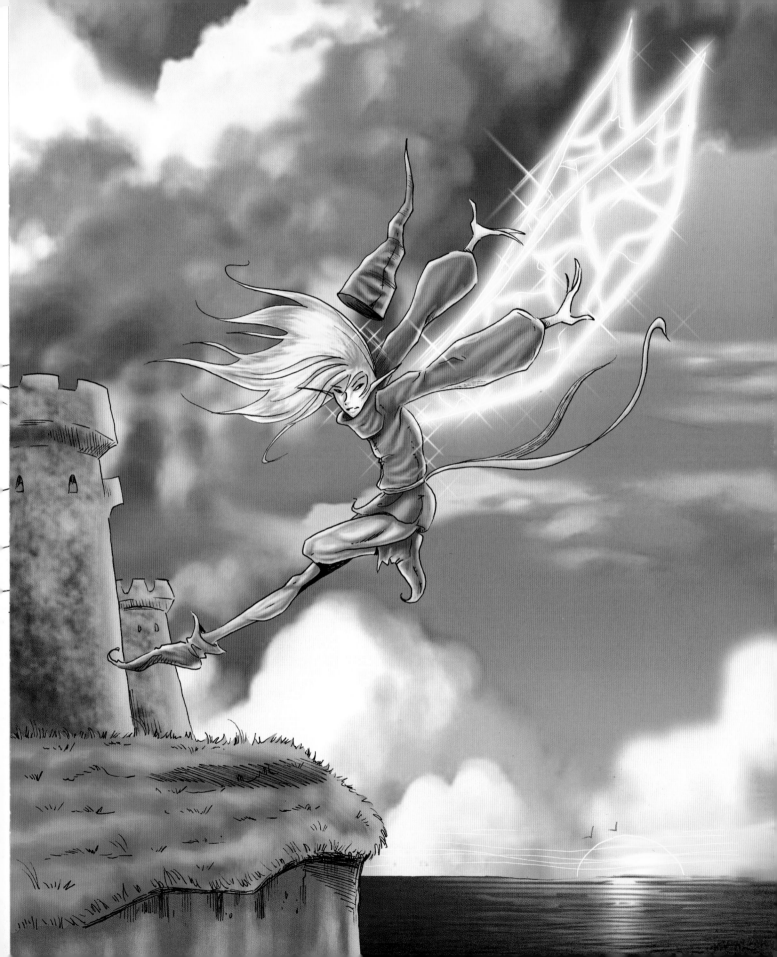

Cradle of Love

There is nothing closer than the bond between mother and child. For the first few months of life, the faerie baby is cocooned in the soft, warm wings of her mother.

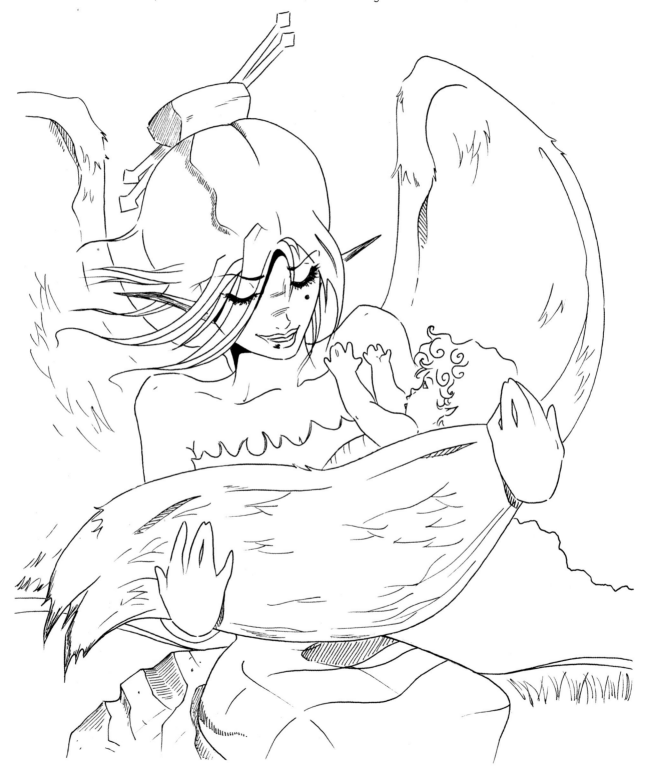

Nature's Umbrella

In addition to flying, there are other ways faeries like to use their wings. This faerie has found hers to be quite useful when caught in the rain.

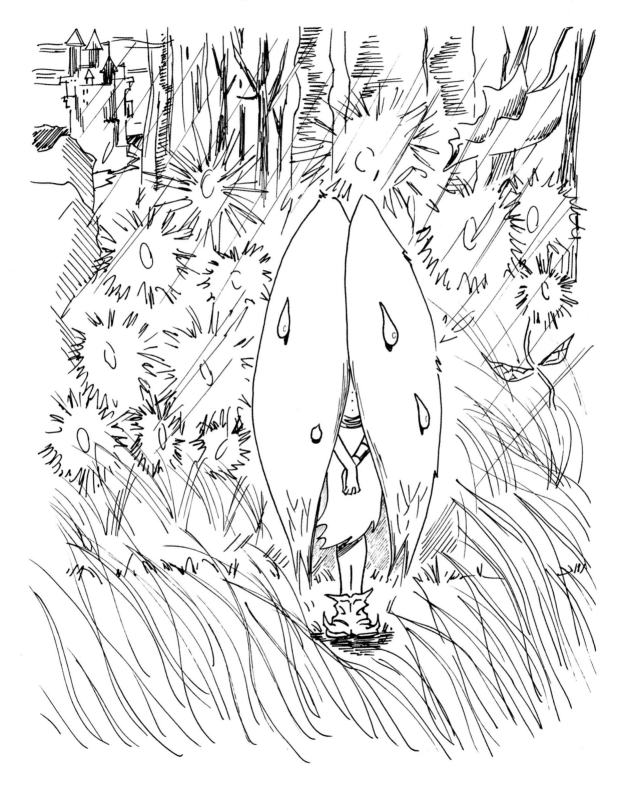

Twilight and the Flight of the Faerie

Since the rebellion, the winged faeries have served as lookouts, flying over the Kingdom day and night, keeping a watchful eye out for Rollo's forces. These dangerous excursions are even more so at twilight, when the light begins to dim and nocturnal predators, like owls, soon appear.

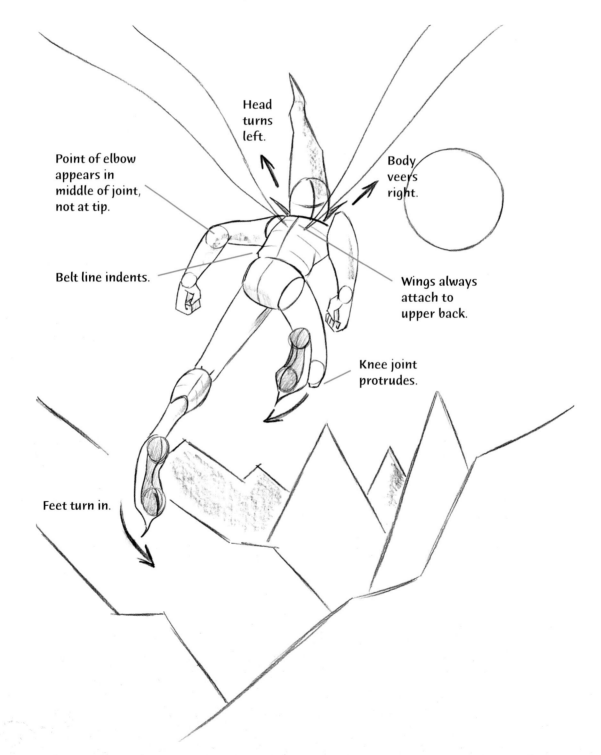

Head turns left.

Point of elbow appears in middle of joint, not at tip.

Belt line indents.

Body veers right.

Wings always attach to upper back.

Knee joint protrudes.

Feet turn in.

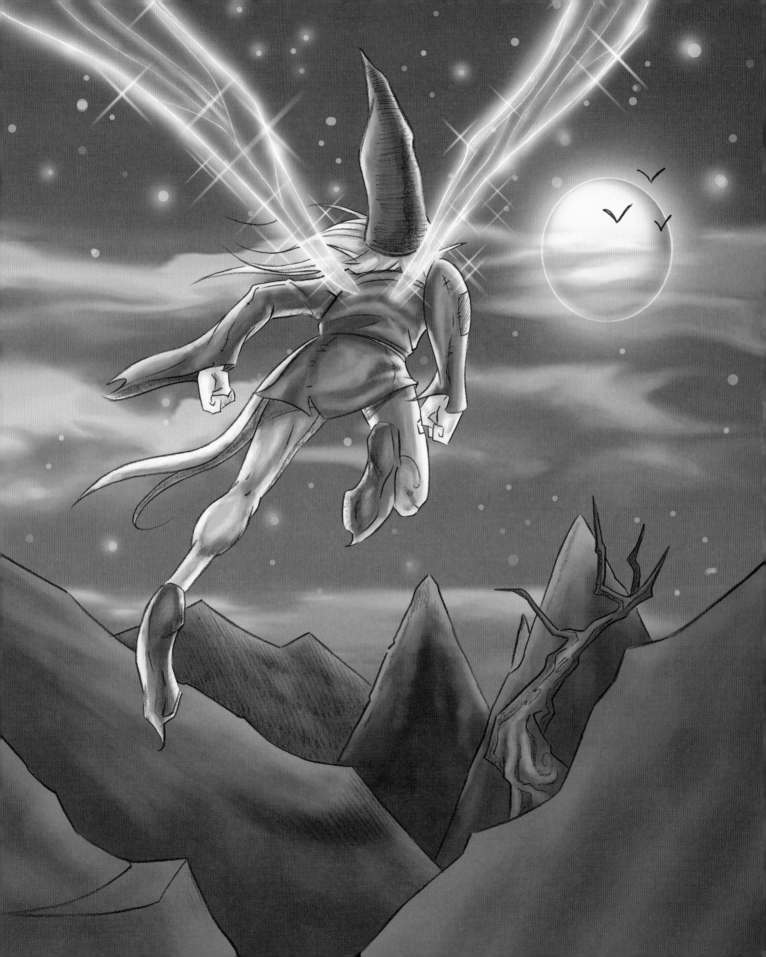

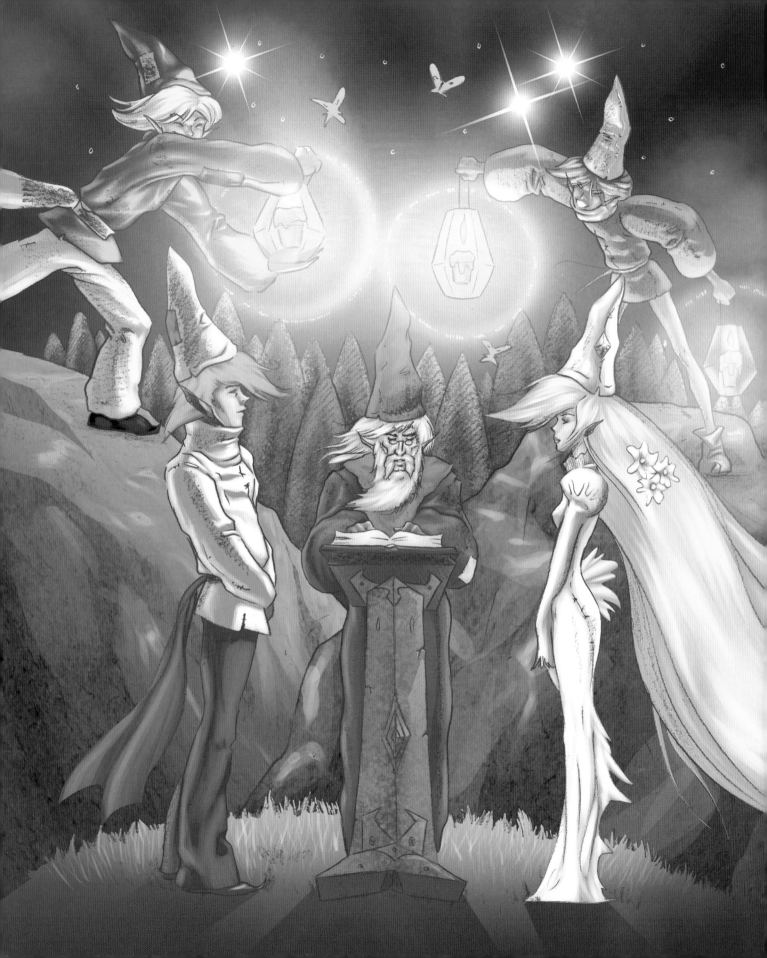

PART THREE

THE ROYAL WEDDING

PREPARING FOR THE FEAST

While small in size, faeries have big, brave hearts. They were undeterred by Ulrich's rebellion and continuing threats of overthrow and invasion. They moved ahead with preparations for the royal wedding. A grand feast was being prepared, and the entire Kingdom readied for a lavish celebration.

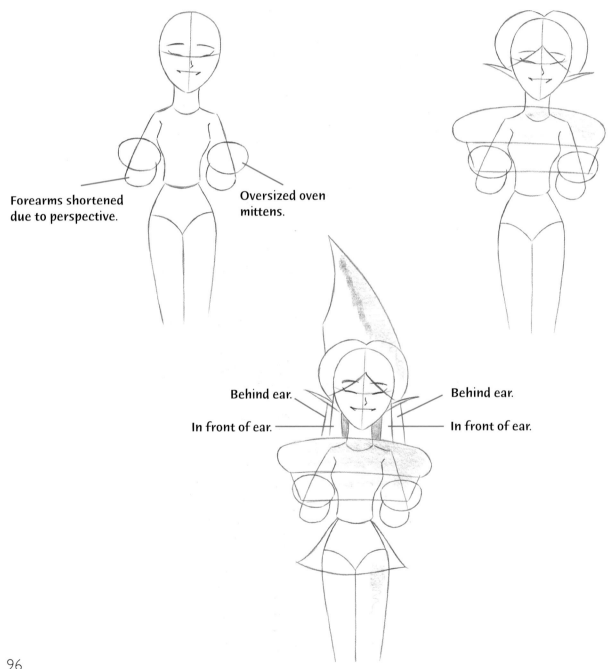

Forearms shortened due to perspective.

Oversized oven mittens.

Behind ear.

In front of ear.

Behind ear.

In front of ear.

Mmmm, Freshly Baked Bread

Sonnett is the baker's helper. She wears a smile throughout the day. I think anyone whose job is to bake hot, fresh bread must find it impossible not to smile continuously.

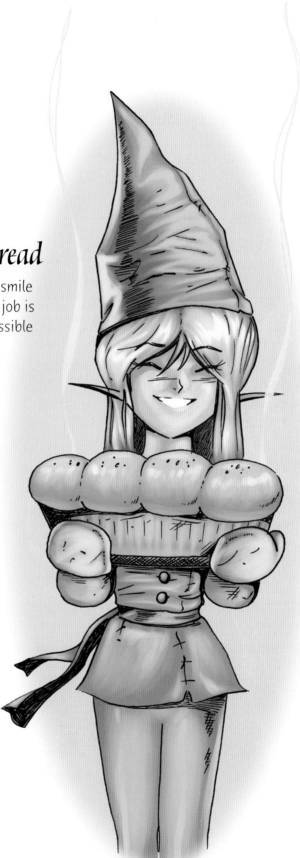

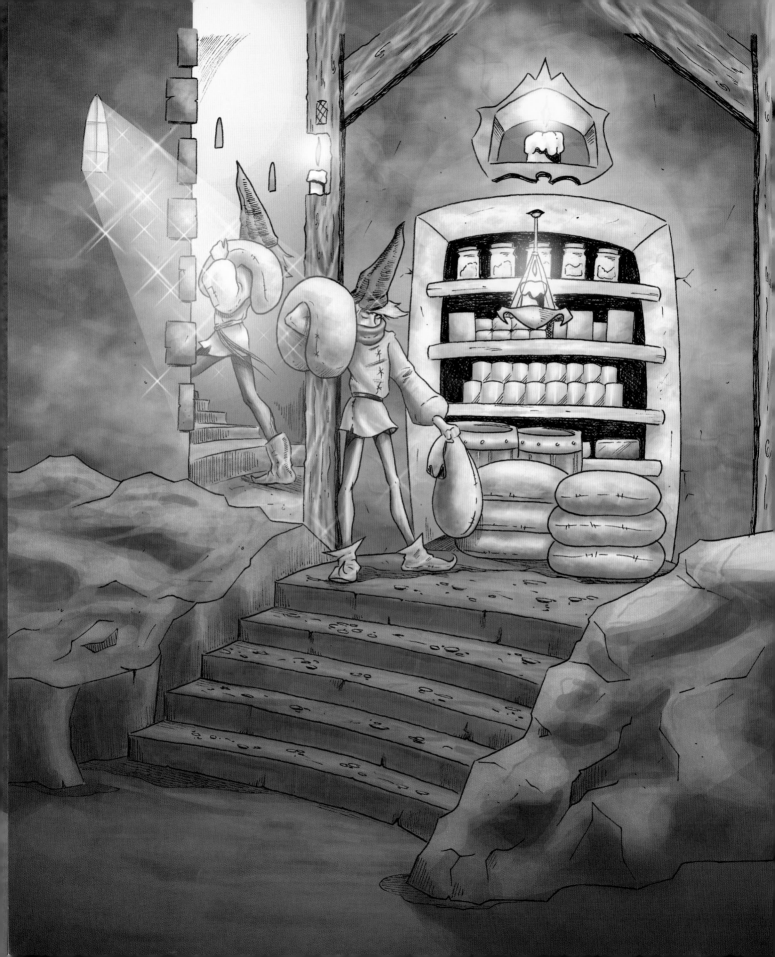

The Staff of Life

Fragrant herbs, spiced fruits, jams, pickled roots, and toasted garden vegetables are some of the delicacies that will be served on the big day. But, perhaps, the most important foodstuffs gathered are the fine cheeses and grains, from which delicious appetizers and breads will be made.

The Great Famine

In the Dark Ages of the Faerie era, a sickness wiped out the entire harvest. The only grain they had to last the winter were in the small leftovers from the previous year, which were less than meager. But due to their determination, and great compassion, not one faerie child perished as a result of hunger--the faeries saved all of their scarce food supplies for the young. But countless were orphaned, and two thirds of the Kingdom succumbed. Every day, you can see someone paying his respects to the memories of the victims of The Great Famine.

I did this sketch in pencil, as pencil is the most sensitive drawing instrument of all. I needed that sensitivity to convey the subject matter.

You get a different effect when you use a different medium to draw the same illustration. Charcoal is far less precise than pencil, and the tone cannot be varied as much. However, it has a rich black texture, and gives a more impressionistic feel. The line is thicker, resulting in a bolder drawing. Since the tone of charcoal is singularly black—offering no shades of gray that a pencil provides--the shading is particularly strong, which is a good fit for this subject matter.

Most illustrators apply color over clean ink lines, and to good effect. However, some of the immediacy and spontaneity of the drawing may be lost when it is inked over the original pencil. A lighter, wistful quality remains when the original pencil sketch is used as the basis for the final color illustration, as was done here.

The Kitchen

In the kitchen of the Master Chef, something good is always cooking, whether it's his famous seventeen-layer cake or his whipped cream banana pie. Of course, everything must be tasted first, to make sure it is just right. The result of all that tasting can be seen on the Chef himself. It's a tough job, but somebody's got to do it.

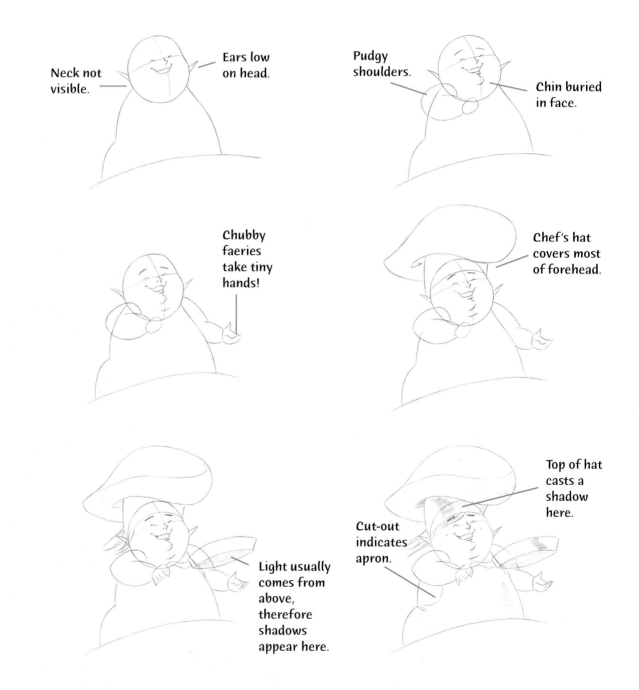

Neck not visible.

Ears low on head.

Pudgy shoulders.

Chin buried in face.

Chubby faeries take tiny hands!

Chef's hat covers most of forehead.

Light usually comes from above, therefore shadows appear here.

Top of hat casts a shadow here.

Cut-out indicates apron.

Yum! Pancakes with lingonberries for breakfast. Although the Chef lives alone, he always makes a few dozen extra. The aroma always brings half a dozen neighborhood kids around on Sunday mornings.

Stirring the Batter

In most human towns, the youngsters can't wait for the day when they get the keys to the car. In the Faerie Kingdom, it's the spoon to the cake batter.

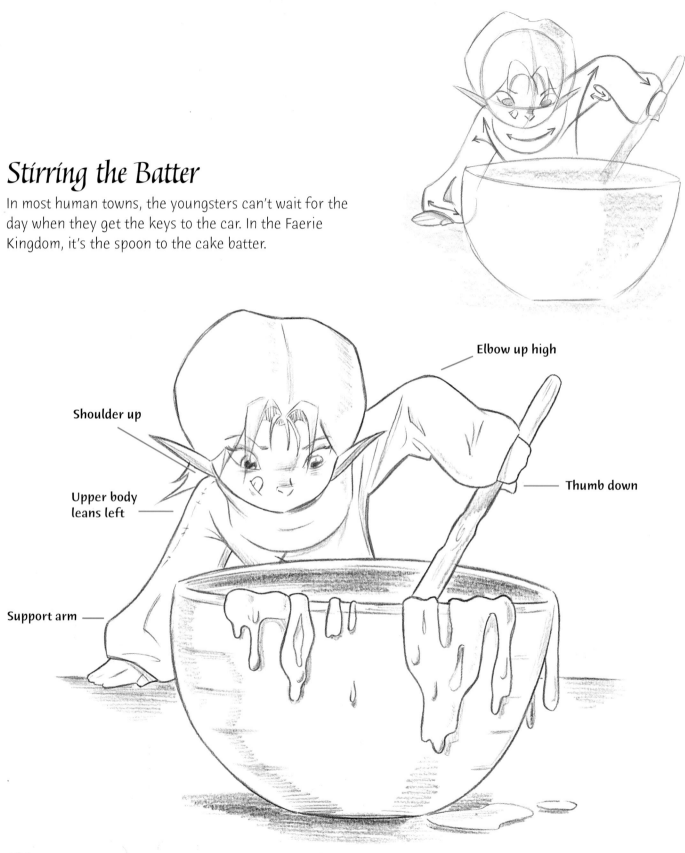

Shoulder up

Elbow up high

Upper body leans left

Thumb down

Support arm

Sneak-a-Treat

They're going to get into trouble for this one. But some things, I suppose, are irresistible and worth the slap on the wrist. And if anything qualifies as that, the Chef's exquisite triple-fudge-chocolate-mud-brownie-walnut wedding cake sure does. These clever rascals know that if they take a slice, it will be instantly noticed. But if there were, say, ten layers instead of eleven, well, who's going to know?

The Royal Clothiers

The royal clothiers have the important task of preparing all of the garments and gowns for the wedding party. They also helped the Princess collect all of the clothing she needs to take along on her honeymoon. Luckily, for those assisting her, the Princess packed lightly.

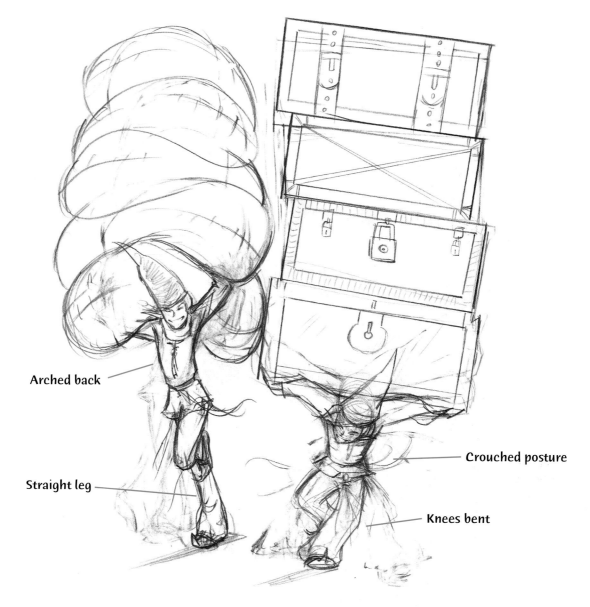

Arched back

Straight leg

Crouched posture

Knees bent

Juxtaposition: Contrasting poses side by side makes for a more interesting picture. Note the differences between the two faeries.

The Tailor

Everything must be just right, so the expert eye of Rolf, the Royal Dressmaker, carefully measures the seams.

Note the foreshadowing of the arm is aided by the wrinkles wrapping around the sleeve.

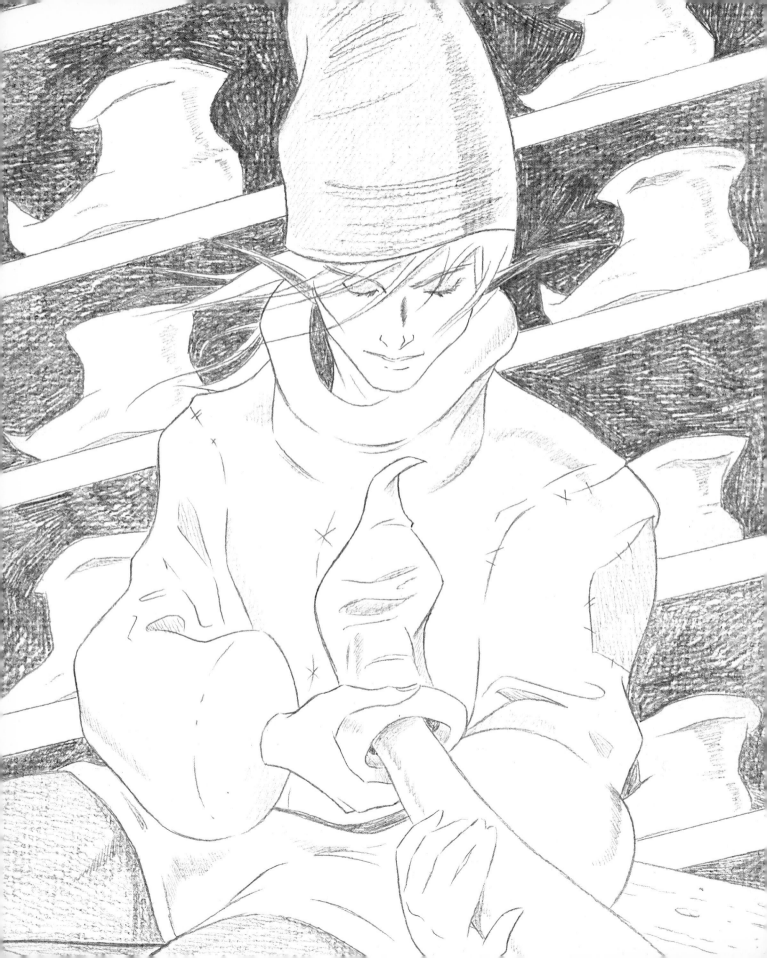

The Cobbler

Rollo says that he's not boasting when he brags that their cobbler is the best in all of the kingdoms this side of the Sweet Water Oceans. He's simply stating a fact.

The shoes for the princess must fit perfectly on her wedding day, because, as it says in the *Great Book of Faerie*, she will be stepping into a new life.

Top of collar rises to back of neck.

Bottom of collar sets deep into jacket top.

Jacket, which is loose, overlaps belt line.

Bottom of leg flattens where it presses against seat of bench.

Eyebrows flow as one continuous line.

When head is tilted down, bridge of nose can be omitted.

Forearm compresses and becomes "flat" as it points directly at us. This principle of perspective is called "foreshortening."

Horizontal lines as a background are tepid.

Diagonal lines are more dynamic.

The leg is never drawn as a straight line, but always shows a subtle curve, even in the front, where it is mainly bone.

Showing a contour line overlapping the other lines creates a sense of depth.

The Difference Between Gnomes and Faeries

Unlike most faeries, gnomes have facial hair—usually long beards and mustaches, but sometimes just chops. Their ears are not as long as those on faeries, nor are their noses. And they're rather portly little fellows. None are capable of flight, which they consider a supreme waste of energy anyway. "No one has ever built a house while darting about in the air," is a common gnomatic refrain, or "gnomum" as they're commonly called.

Gnome

- Facial hairs (beards, mustaches or chops).
- Portly, but sturdy body.
- Short arms and legs.
- All-weather boots with no curled-up toe.
- Hat is shorter, less pointy.
- Hair is shorter, bushy.
- Tiny, chubby hands.
- Thick eyebrows.

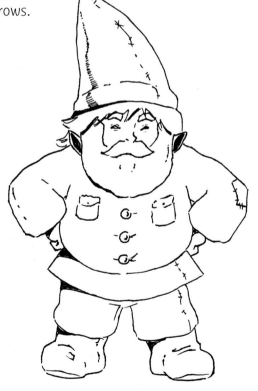

Faerie

- Lanky build.
- Long limbs
- Long, pointy ears.
- Tall, pointy hat.
- Curled-up toe.
- Flowing hair.
- Thin eyebrows.
- Rarely any facial hair.

Drawing the Gnome Face

Here are the secrets for drawing the gnome face: The head is round, the features are clumped together in the center of the face, and the chin is buried inside of the outline of the face. Just remember those three hints and you can't go wrong!

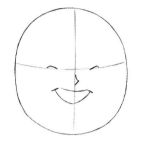

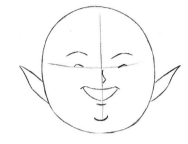

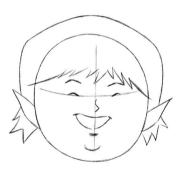

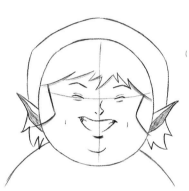

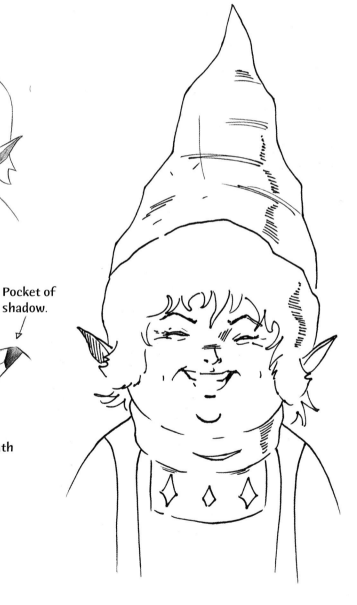

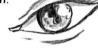

Eye open.

Eye happy
(curves down).

Eye sad
(curves up).

In a wide grin, show
pockets of shadow
at both ends of the
mouth.

Pocket of
shadow.

Shadow Under Mouth

The Gnome Physique

Gnomes and faeries couldn't be built more differently. Gnomes are short and compact, whereas faeries are light and lean. I must say that I find the gnomes' self-seriousness a bit amusing, but I do admire them. They have a very strong social network, and are never seen alone, preferring to work in pairs. And while they have rather gruff personalities, they are extremely soft hearted, and are always the first on the spot to help friends in need.

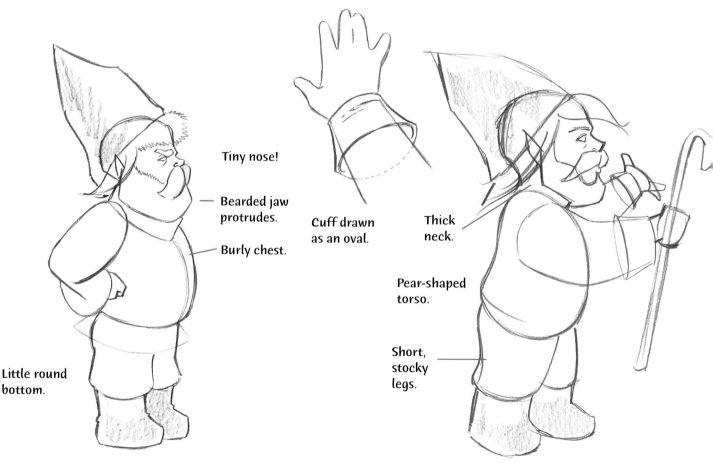

Tiny nose!

Bearded jaw protrudes.

Burly chest.

Cuff drawn as an oval.

Thick neck.

Pear-shaped torso.

Little round bottom.

Short, stocky legs.

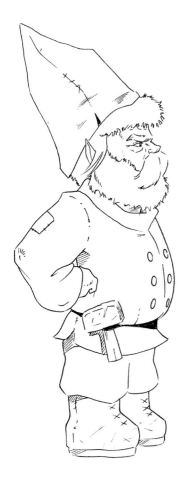

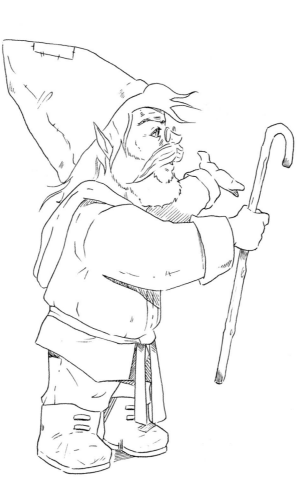

These two brothers, Jacob and Jonah, are trying to explain to a bullfrog why it's annoying to croak in the early morning hours right outside their window. Unfortunately, the bullfrog is unconvinced, because all of his bullfrog friends have told him he has a melodious voice.

Drawing Gnome Boots

Gnomes don't wear long, pointy slippers, as faeries do. No, they prefer more practical, sturdy boots. They need the extra protection, as gnomes always keep their feet firmly on the ground.

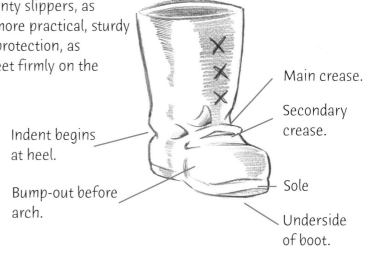

Main crease.

Secondary crease.

Sole

Underside of boot.

Indent begins at heel.

Bump-out before arch.

The Big Day

The big day arrived with much rejoicing. The entire Kingdom came to witness the ceremony and share in the celebration. Everyone, that is, except Ulrich and his followers. For try as they might to ram the fortress doors, Rollo's locks held, and continued to hold all through the day and into the night. Princess Ambrosia and Prince Johan were finally married and there was much happiness and joy everywhere.

It's so poignant when someone is getting married. I mean so happy. I mean poignant. I mean happy. Well, I suppose it all depends on which bridesmaid you talk to.

The Bride and Bridesmaids

Here is a scene drawn in a fairly straightforward manner, which would make good practice for you to try. The composition is clear. The charm of the scene is created by the interplay of expressions between the three characters--the humor being that the calmest one is the one who is getting married! As you can see by the hints I've provided, many techniques go into drawing a scene, which when successfully incorporated, make it all look simple. But these are things that are consciously labored over, so don't be discouraged if they don't come naturally to you at first. They don't have to. They only have to *look* natural in the final result!

A) Rib cage is a discreet shape.
B) Foreshortened limbs are most effective if drawn on a diagonal.
C) Show hourglass figure.
D) Square sholulders are appealing on females.
E) Vary the heights of the characters.
F) Different characters smile differently. The princess' lips curl up; the bridesmaid's curl down.
G) Shoulders rise when a character tenses.

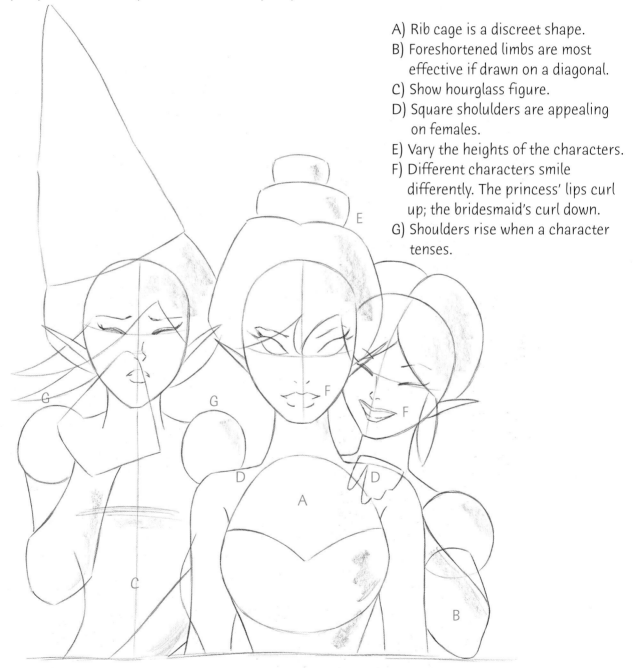

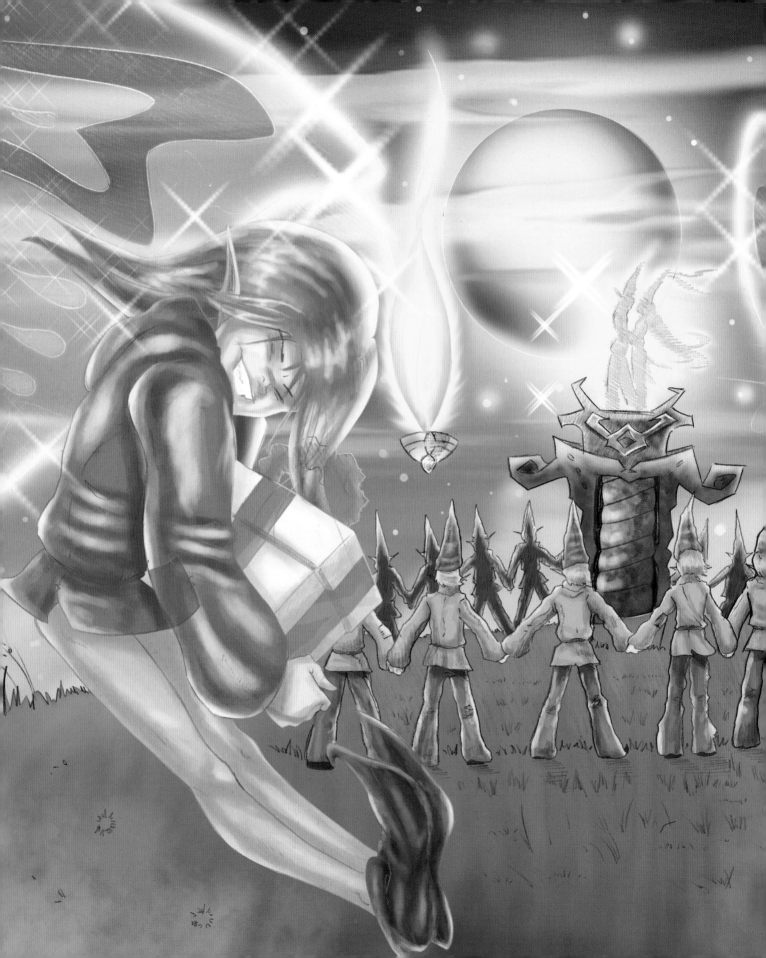

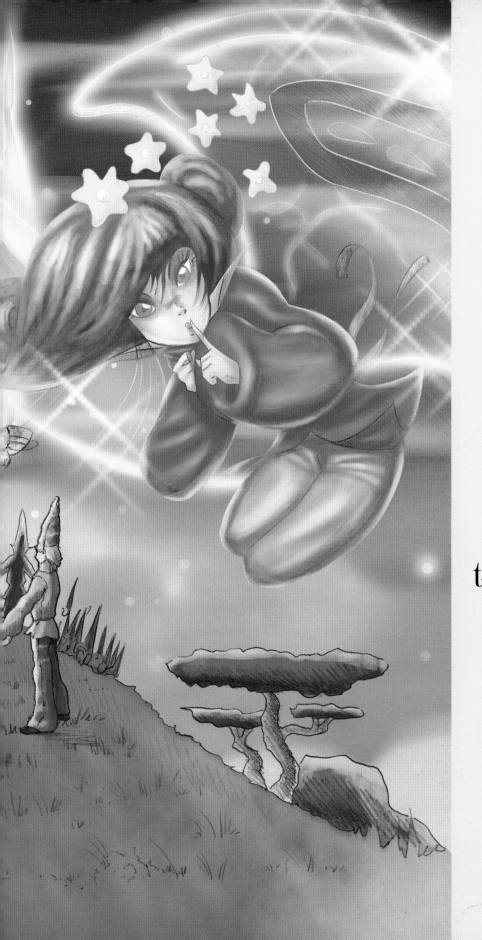

The King of the
Faerie Kingdom
requests the honor
of your presence at
the marriage of
his daughter
Princess Ambrosia
to Johan of the Arbor

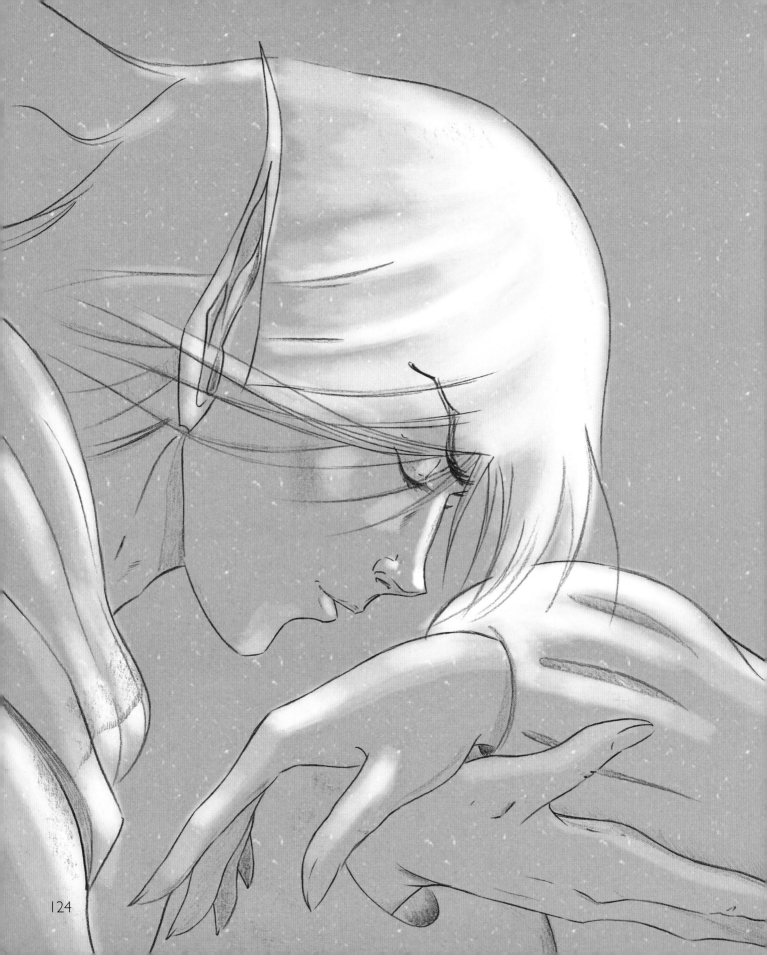

124

The Princess graciously received her many, many gifts, but she seemed especially touched by the portrait given to her by her dear friend Rollo (which, naturally, made this artist very proud).

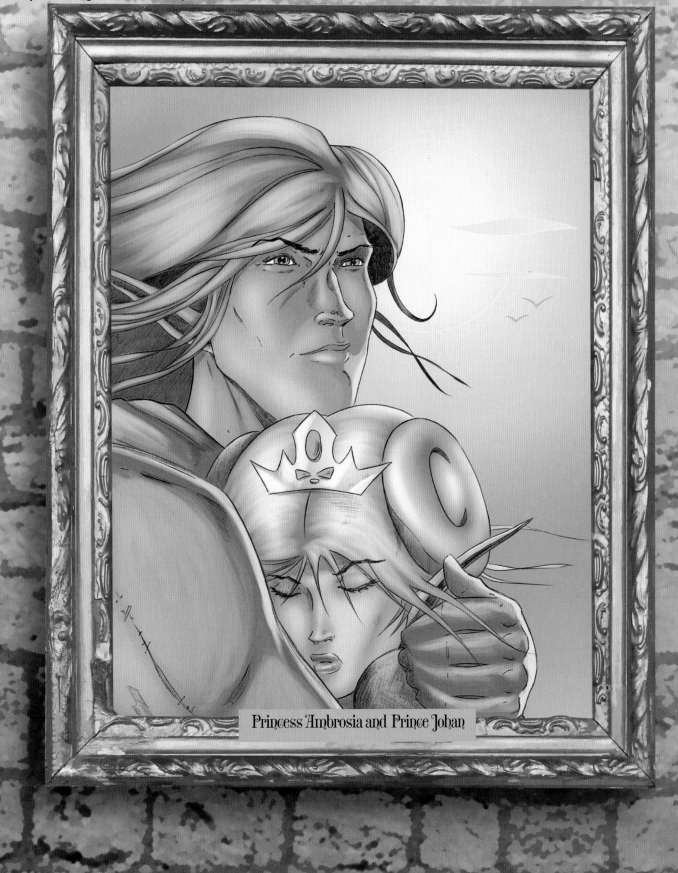

Princess Ambrosia and Prince Johan

To Dream the Dream of Faeries

When I awoke, it took me several moments to realize that I had been dreaming. I made myself a cup of the world's worst coffee and padded into my studio. I picked up my work and looked it over, expecting to groan. But I didn't. It looked the same, yet, completely different. The drawings seemed inspired, with a magical quality. Had I misjudged my work so greatly the night before? Could it have somehow changed while I was sleeping? Could it have been more than a dream? No. Believing that is just too fantastic.

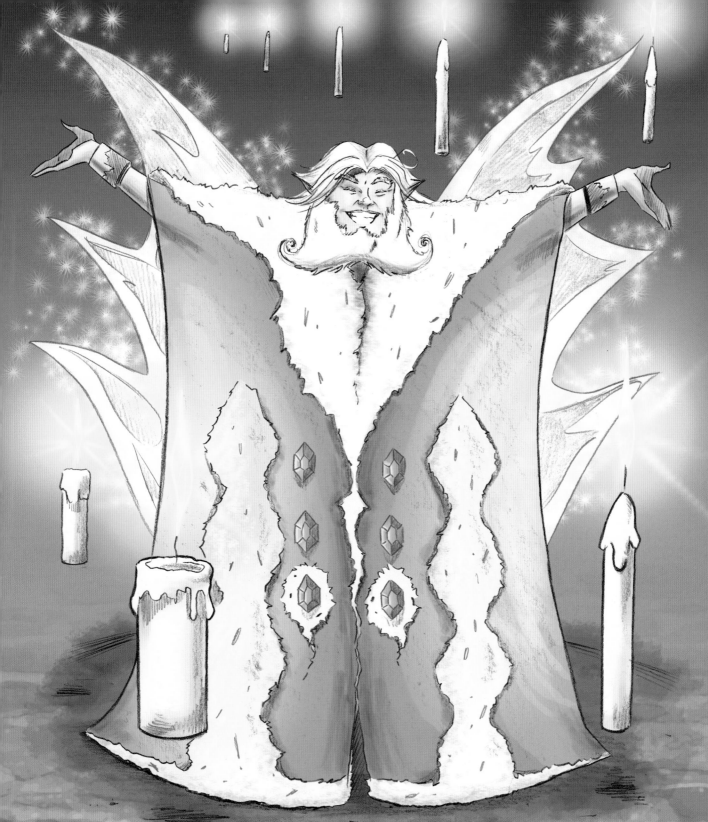

My thoughts often drift back to the Faerie Kingdom. I wonder if they are still at peace, or if they are once again under a state of siege. And if the dark times have again come upon them, I wonder if they can escape, as I did, through the gateway of dreams, to return to the happy days and sweet times that seemed to last forever.

I believe you can make a similar journey. If you close your eyes, you can visit them, too. And there, they will be waiting, for you.